How the New Art of Eurythmy Began

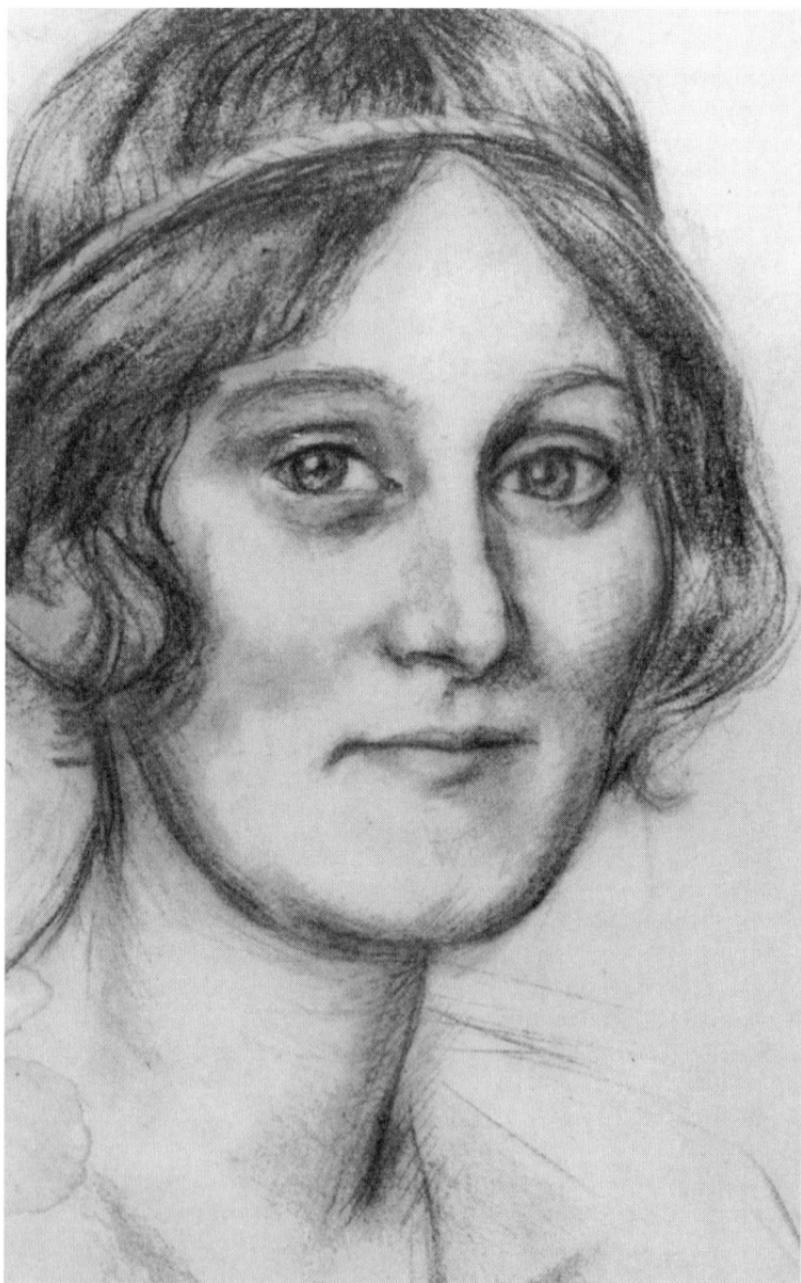

Lory Smits
Red chalk drawing by Claus von der Decken

HOW THE NEW ART OF EURYTHMY BEGAN

Lory Maier-Smits
The First Eurythmist

Magdalene Siegloch

TEMPLE LODGE
London

Translated from the German

Temple Lodge Publishing
51 Queen Caroline Street
London W6 9QL

Published by Temple Lodge 1997

Originally published in German under the title *Lory Maier-Smits, Die erste Eurythmistin und die Anfänge der Eurythmie* by Verlag am Goetheanum, Dornach, Switzerland in 1993

A catalogue record for this book is available from the British Library

ISBN 0 904693 90 2

Cover by S. Gulbekian. Cover photograph: Lory Smits, 1913 in Haus Meer
Typeset by DP Photosetting, Aylesbury, Bucks
Printed and bound in Great Britain by Cromwell Press Limited, Broughton Gifford, Wiltshire

Contents

Preface

The actual moment of birth of the various arts is not known. At most, significant changes of direction are distinguishable— and these are usually determined afterwards. It is one of the signs of our time, after the end of the so-called Dark Age, Kali Yuga, that the moment of birth of a new art of movement, eurythmy, is well documented. This phenomenon in human history can be interpreted as a moment of consciousness, as a preview of the new Age of Light.

Rudolf Steiner describes this hour of birth in relation to Anthroposophy: 'Eurythmy actually grew up on the ground of the anthroposophical movement like a gift of destiny.' (Lecture of 26 August 1923 in Penmaenmawr.)

From this perspective, since Rudolf Steiner's lectures provide the wider background for the earliest efforts in eurythmy, Magdalene Siegloch's exact yet artistic way of describing and quoting them is very valuable.

Not only trained eurythmists will gain an expanded access to the seeds of this new art of the twentieth century, but also every contemporary person who is interested in eurythmy and who wants to form his own picture of it. The descriptions of its development are so lively that one can easily feel that one was there.

At the end of the twentieth century now, looking back, we can see that just especially this century brought forth many pioneers in areas which had been unimaginable before: space travel, deep sea research, communication technology, etc. Therefore it is that much more remarkable that Rudolf Steiner is receiving more and more recognition from representatives of culture and science. There have also been other highly gifted individualities who have been able to unfold their work as significant pioneers through Rudolf Steiner's help and

inspiration. The publisher Verlag am Goetheanum has devoted a number of books to pioneers in Anthroposophy already. With the present volume *How the New Art of Eurythmy Began* the reader gains insight into many facets of the life and work of the pioneers of the newest art, the art of eurythmy. For the Section for the Arts of Eurythmy, Speech and Music of the School of Spiritual Science at the Goetheanum it is most gratifying that this documentation about the first eurythmist could appear in the very year of its major World Eurythmy Conference (Easter 1993 at the Goetheanum, with 1100 qualified eurythmists attending). After having been urged by many colleagues to write this book, Magdalene Siegloch took up the task with modesty and yet with great competence. As a eurythmist and eurythmy teacher of many years, she was also able to provide the contact with the Maier-Smits family, thus she was as no other person predestined to write it.

When this important book appeared in German in 1993 it was immediately obvious that its contribution to the history of eurythmy was indispensable also for the English reading public. A generous grant has now made this possible. The book is a further important step in the research and development of the impulses of Anthroposophy. The birth of eurythmy can really be seen as a special moment in the biography of Anthroposophy.

Virginia Sease, June 1997
Section for the Arts of Eurythmy, Speech and Music
Goetheanum

Foreword

Two main tasks shaped the life of Lory Maier-Smits: one was the exceptional task, as a young girl, of dedicating her whole being to the instructions of Rudolf Steiner, which led to the development of eurythmy; and the second arose through her personal destiny within the circle of her own family, which likewise required her full devotion.

She herself told us about the first task: in 1951, in a newsletter for members of the Anthroposophical Society in Germany,[1] and in 1956 in a book for the public.[2] In 1962 Edwin and Eva Froböse asked her to describe the lessons she had had with Rudolf Steiner, in as much detail as possible, so that they could be included in a comprehensive documentation of eurythmy. Thanks to Eva Froböse's warm interest in the progress of the manuscript, and to the excellent way in which she brought out the book, it became the most comprehensive and exact description of the beginnings of eurythmy available to future generations of eurythmists.[3] In this biography the three sources mentioned above will be frequently quoted from. Some quotations were taken from the handwritten draft.[4]

I also wished to add to Lory Maier-Smits' own magnificent descriptions some themes from the life of the anthroposophical movement, for this was a vital source of motivation for her, and the foundation upon which eurythmy arose.

Lory wrote very little about the other main task in her life, her destiny with the Maier-Smits family. There are a few letters to her mother from the years 1915 and 1918; also letters to Margarita Woloschin and Ruth Vogel from 1959 to 1967. The picture has been enlivened and extended with the help of personal, verbal reminiscences provided by her daughter Johanna Maria Tschachotin and others who were close to her. I extend my cordial thanks to these people.

Magdalene Siegloch

1.
1893–1913. Preparing for the exceptional task; Lory Smits' family and the Theosophical Society

During the festive International Summer School[5] in Penmaenmawr in 1923 there were five eurythmy performances. Rudolf Steiner gave a special lecture introducing a new art of movement, which began with the following words:

> Eurythmy actually grew up on the ground of the anthroposophical movement like a gift of destiny. In 1911 it happened that an anthroposophical family lost its father. His daughter sought a career, one that should come out of the anthroposophical movement. Thus it came about [...] that an art of movement could be inaugurated that had not existed until then. So the very first forms and principles of eurythmy actually grew out of the instruction given to that young lady.[6]

The daughter looking for a vocation in 1911 was Lory Smits. She was 18 years old when Rudolf Steiner agreed to train her for a career that did not yet even exist. The decision to do this was taken in a single conversation. In retrospect however, the events of her childhood and youth can be felt as a hidden preparation for the great mission which was approaching her.

If we look at the development of anthroposophy—until the year 1912 within the Theosophical Society, and afterwards within the Anthroposophical Society—we can see that the new level of artistic creation which Rudolf Steiner achieved in his mystery dramas needed a new art of movement to give it full expression.

Eleonore Clara Maria Smits-Mess'oud Bey was born on 6 March 1893, in Höntrop near Bochum, Germany. She was the

second of six children. Her father, Henri Felix Smits, was Belgian. Her grandfather was a colonel in the Turkish military, where he had received the foreign part of his name as an honorary title. In the Smits' home there were many precious objects from the Orient. Eleonore's father was a mining engineer—he brought home treasures of a different kind, for example large pyrite crystals in the shape of very beautifully-proportioned pentagonal dodecahedrons. One of them was given to Rudolf Steiner as a gift. Her father's suave and engaging personality made him rather popular, and he was admired by the young ladies as an outstanding and elegant dancer. Eleonore's mother was a purposeful individual, occupied with serious thoughts, who was strict in bringing up the children. Soon after the birth of Eleonore the family moved to Burbach an der Wied, where her father worked for a mining company.

Lory—as she was called throughout her life—was 5 years old when her 3 year-old brother Hänschen died of appendicitis. His sudden death started her mother on a search for something that could give meaning to it. She had previously been inclined to atheism, but now neither science nor religion provided ideas that satisfied her. During this period she made a bicycle trip with a lady acquaintance. She fell from the bicycle, but was not hurt. In the ensuing conversation, Clara Smits told her companion about her doubts and her pain. Her companion suggested that she look into the theosophical idea of reincarnation, which she did.

About 1900, when Lory was 7, the family moved to Düsseldorf-Oberkassel, where there was a branch of the Theosophical Society which Clara joined. It was not a very active branch, however, and it became still less so. In 1903 it was closed 'because of various unfortunate circumstances'.[7]

Clara Smits' search for people with a common interest in Theosophy remained disappointing until a friendship arose with the theosophist Mathilde Scholl, who lived in Bonn. In a letter to Marie von Sivers in 1903, Mathilde wrote: 'Very stimulating for me is my contact with a theosophist who lives

near Düsseldorf, Mrs Clara Smits. We often visit each other, and we write to each other frequently.' Their connection became still closer when Mathilde Scholl moved to Cologne during 1903.

Rudolf Steiner was giving courses and lectures to all sorts of different groups, all of whom believed themselves to represent *the* modern view. They did not respond to what he saw as his own mission: to tell people about the results of his supersensible research and to show them how they themselves could attain knowledge of supersensible reality. He did not meet with any willingness to take up such themes until he was invited to speak to a group of theosophists. A series of weekly lectures evolved from this, at the Theosophical Library in Berlin. These attracted such interest that he was asked in February 1902 to become the General Secretary of the German Section of the Theosophical Society, which was to be refounded. He made it clear to the theosophists in Berlin, and to Annie Besant, the leader of the international Theosophical Society, that he would be representing only his own supersensible experience. This was anthroposophy, cultivated from 1913 onwards in the Anthroposophical Society. Rudolf Steiner agreed to accept the office of General Secretary only on the condition that Marie von Sivers worked together with him. This she was prepared to do, and so the German Section was founded in Berlin. Rudolf Steiner immediately considerably expanded his courses at the Theosophical Library, although for the time being he also kept up his teaching and lecturing at other Berlin institutions.

Rudolf Steiner's first public lecture, 'The Fundamental Doctrines of Theosophy—Man and the World Mysteries', was not held in Berlin but Düsseldorf. It took place at the largest concert hall of the city, on 4 February 1903. Clara Smits was deeply impressed by the content of the lecture and by the personality of the speaker. It was she who promptly asked him to come regularly to Düsseldorf. When Steiner gave a lecture in Cologne in November 1903, Mathilde Scholl arranged a private meeting for the two Düsseldorf members, Bernhard

Clara Smits (Reuß-Zaefferer), born 1863 in St Johann near Saarbrücken, died 1948 in Laufenburg/Baden. Mother of Lory Smits.

*Pierre Felix Smits
Mess'oud Bey (1819–
1885). Grandfather of
Lory Smits. (Left.)*

*(Below.)
Henri Felix Smits
Mess'oud Bey, born
1863 in Vienna, died
1911 in Düsseldorf.
Father of Lory Smits.*

Lohfs and Clara Smits, presumably so that they could discuss the future of their branch. The following month Clara Smits received a letter from Rudolf Steiner with indications for her personal esoteric development.[8]

In 1904 there were two further public lectures in Düsseldorf—in February: 'Theosophical Ideology and the Goals of the Theosophical Society', and in March: 'The Soul and Human Destiny'. On 29 November he spoke on a theme very relevant at the time, 'Theosophy and Haeckel's Mystery of the Universe'. After these preparations, the sleeping Düsseldorf branch could be reawakened. This took place on 30 November in the house of the Smits family, as did all further members' lectures. Clara Smits became the treasurer of the new managing committee. Rudolf Steiner subsequently often stayed at the Smits' home. Lory later described this:

> I was 11 years old when I saw him for the first time. To my distress, right from the start he addressed me formally, as if I were an adult, 'because that is how it is done in Austria.'[9] I very much envied my younger sisters, whom he often held in his lap, and with whom he played.

In the years 1905 and 1906 Rudolf Steiner gave 26 lectures in Düsseldorf, mostly for members of the Theosophical Society. By 1909 the branch had grown enough to require a larger meeting place in the centre of town. The Smits family moved in 1910 to the fashionable residential estate 'Haus Meer', where there were only about seven houses, all with very large gardens.

Rudolf Steiner had lecturing commitments in many German cities. A special event in 1907 was the Second Annual Meeting of the 'Confederation of the European Sections of the Theosophical Society' in Munich. To the great surprise of the members, who came from all over Europe, Rudolf Steiner had arranged for the entire main assembly hall to be decorated in an unusual way: the forms and colours were intended to emphasize the content and the mood of the meeting. An equally amazing innovation was the staging of *The Sacred*

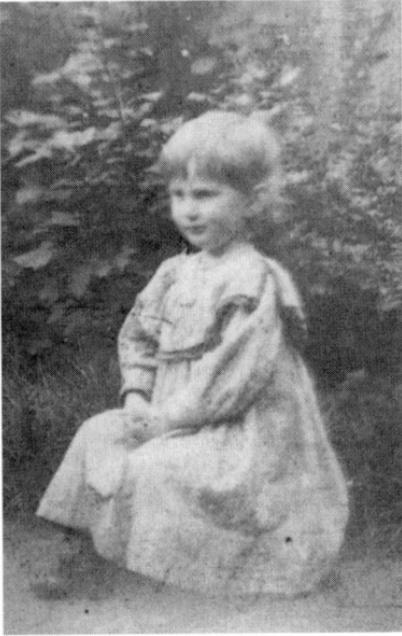

Lory Smits, about 5 years old.

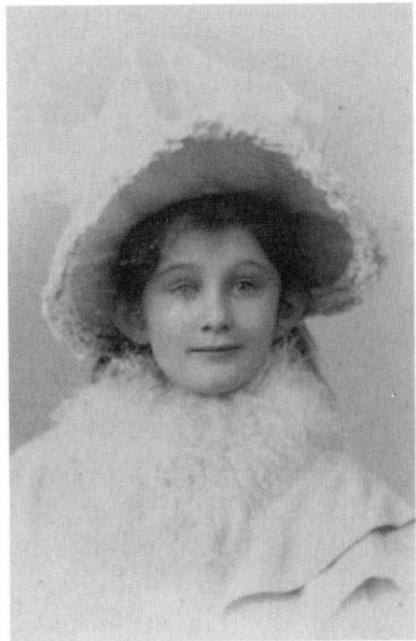

Lory Smits, about 11 years old.

Drama of Eleusis by Edouard Schuré. All this meant that the person striving for higher knowledge was to be addressed not only as a thinking, understanding being, but also as one with artistic feeling.

In December of that eventful year Rudolf Steiner gave a lecture to members at the Smits' house in Düsseldorf. This was a quite natural opportunity for Lory to attend. She later wrote: 'I was allowed to listen to a lecture already in 1907, once he realised that my eavesdropping was not just curiosity or a craving for sensation. I still clearly remember that he spoke about the Rose Cross. . . .' In this lecture Rudolf Steiner described how supersensible reality has become less and less perceptible to mankind. Since the beginning of modern times our whole attention has been taken up with researching the laws of the visible world. Yet we can now find our way back to a perception of supersensible reality. There is a way to do this that is right for our epoch, which takes its starting point from the visible world.

A passage from this lecture reads:

The teacher said something like this [to the pupil]: Look at the plant, how it strives towards the sun with its leaves and blossoms, and sends its roots into the earth, striving towards the centre of the earth. If you compare it with the human being, you find the opposite [. . .] The human being is a reversed plant. The root which the plant sends down into the earth corresponds to the head of the human being. But the blossom and reproductive organs, which the plant chastely holds up towards the sun, the human being turns towards the earth. If we turn the whole plant completely upside down, we have the human being; if we turn it only half way, we have the animal, with its horizontal spine.

If we picture these things imaginatively, then not only our thoughts, but also our sensation and feeling will be led deeply into the world surrounding us. We learn to recognize the inner relationship between the plant and the human

being. We recognize the pure chaste nature of plants, which is not yet permeated by desires and passions, and the nature of man, in whom the chaste substance of the plant has been transformed into flesh permeated by desires and passions. But this also brings something higher into our being; because of it, we have achieved clear day-consciousness. The plant sleeps, but we have achieved clear day-consciousness by being incorporated in flesh permeated with desires, passions and instincts. For this we had to carry out a complete, upside-down turn. The animal is between the two. It does have desires and passions, but has not yet achieved clear day-consciousness.

The teacher said to the pupil: When you feel this, then you will understand why Plato says that the world-soul is crucified on the world-body. Plant, animal, the human being—this is the real, deeper meaning of the sign of the cross. What streams through nature as soul, appears as a symbol in the form of the cross.[10]

Rudolf Steiner went on to say that in future epochs human souls would learn to overcome their desires and passions, and that the symbol of the cross with the red roses can stimulate the development of a purer, higher state.

In this multifaceted lecture covering a wide range of connected themes, it was the motif of the Rose Cross which especially made an impression on Lory. She absorbed it with the openness of her 14 years, but also with the earnestness and intensity that the situation demanded. This motif would become a guiding star for her future endeavours, even if she was unaware of it at first.

From then on Lory was permitted to hear all of Rudolf Steiner's lectures in Düsseldorf. At the age of 16 she even heard the lecture series *The Spiritual Hierarchies*.*[11] Two

* Editor's note: The titles of Rudolf Steiner's lectures have been put in italics in cases where a translation has been published under that title in English.

On a flowering cherry tree in the Garden of Champions in Oberkassel, about 1905/1906.

hundred and fifty members of the Theosophical Society also attended this festive event. They came from all over Germany and from neighbouring countries. 50 years later a young lady rather naughtily asked Lory, 'Did you understand those lectures?' Whereupon she replied with great earnestness, 'Yes— the heavens were open'.

At the end of November 1911 Henri Smits-Mess'oud Bey died unexpectedly of heart failure, at the age of 48. He had, with benevolent interest, watched his wife involving herself in the anthroposophical world view—but without participating himself. As a broadly educated and refined sort of person, he had cultivated a friendly, open relationship with Rudolf Steiner. Rudolf Steiner now sent a telegram to Clara Smits (at a time when he could not yet have received word of her husband's death): 'My thoughts are with you.' In the following years Rudolf Steiner often mentioned him to the Smits family. And when he spoke to the members of the Anthroposophical Society about eurythmy, he often said that it was the destiny of this death that had led to the beginnings of eurythmy.

Two weeks after the quite unexpected death of her husband, Clara Smits went to Berlin to see Rudolf Steiner.

While waiting in the outer room she heard that the daughter of an acquaintance was very happy teaching Mensendiek gymnastics. This reminded Clara that her own agile daughter loved to move, and had already considered work of this kind. During her subsequent conversation with Rudolf Steiner, he suddenly asked about Lory. Clara told him that Lory would now have to take up a career, and she mentioned what she had just heard in the waiting-room. Steiner answered with the often cited words, 'Yes, one can of course be a good theosophist and do Mensendiek gymnastics on the side, but the two have nothing to do with each other. One could however base such work on theosophy, and I am willing to show your daughter how.'

He added that he had already made such a suggestion but it had not been taken up.

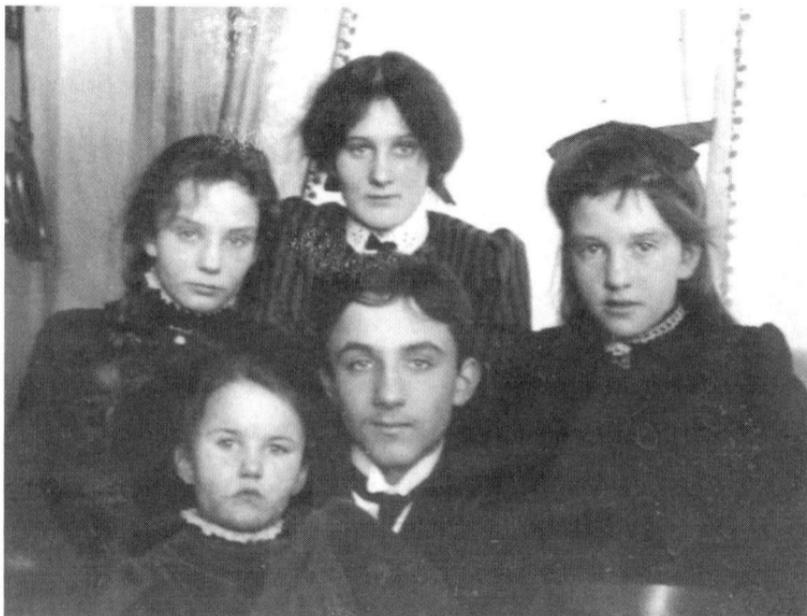

Brother and sisters. Back row: Ellen, Lory and Ada;
front row: Thea and Henri.

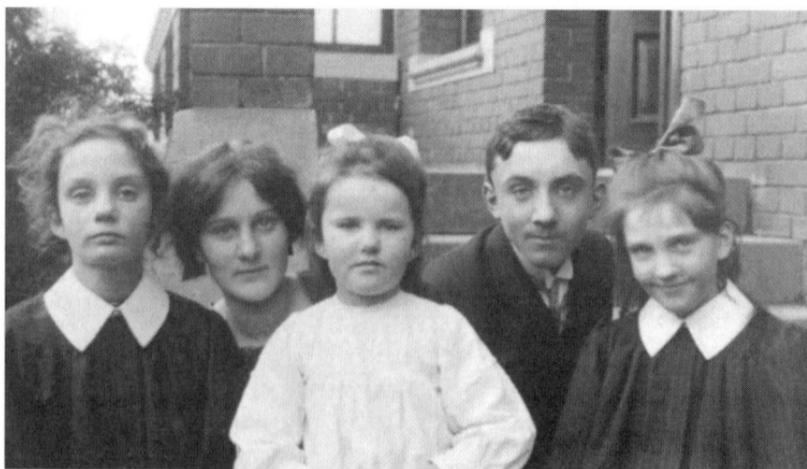

Ellen, Lory, Thea, Henri and Ada.

Clara Smits was able to respond, for she had already been pondering whether the human etheric forces[12] could be stimulated and strengthened through rhythmic movements, so initiating a healing process. The thought had come to her after hearing a particular lecture by Steiner in 1910.[13] When she spoke of it now, Rudolf Steiner answered in the affirmative and also said that, for the time being, this new art of movement would involve moving to the spoken word rather than to music.

This statement surprised Clara Smits, just as it still surprises people today to hear about the art of *visible speech*. To help her understand the connection with speech, Rudolf Steiner showed her a few paragraphs from his book *Cosmic Memory*.[14] These describe the reciprocal action of rhythmic language, rhythmic movement and human soul activity existing already in earliest times as an expression of what is specifically human. In that far distant past, known as the Lemurian Epoch, there were wise priestesses who acted in accordance with the great leaders of mankind.

When these women were in a certain higher state of dreaming, the secrets of nature unveiled themselves, and they received impulses for their actions. For them everything was filled with soul; it showed itself to them in soul forces and soul phenomena. They were driven to their actions by inner voices, or by what was told them by plants, animals, stones, wind and clouds, the rustling of the trees, and so on [...] Thus it could come to pass that what lived within such women could transform itself into a kind of nature language [...] The force of thought transformed itself into an audible force of sound. Nature's inner rhythm sounded from the lips of wise women. Others gathered around them, feeling the expression of higher powers in their song-like sentences [...] There can be no question of 'meaning' in that which was uttered. Sound, tone, and rhythm were felt [...] Thus they could have an ennobling effect on human souls. We can say that the life of the soul

was first awakened in this way [. . .] The mysterious rhythms that had been heard in nature were imitated by one's own limb-movement. One felt thereby *at one* with nature and with the powers working within it.

Rudolf Steiner explained to Clara Smits that not only 'soul' came into humanity in this way. Through these rhythmic dances, called up by the tones and rhythms of the wise priestesses, the first seeds for the organs of speech could be formed in a humanity that was, at that time, still incapable of uttering words.

Clara Smits often spoke to her daughter Lory about this important conversation:

How Rudolf Steiner had said that there was indeed a new kind of movement, based on the movements of the etheric body[15] as she had rightly felt, which he had long wanted to bring into the work; how he had more and more come to see it as indispensable [. . .] How it is needed because there are things so deep that they cannot be expressed in words. It is needed because there are things that would require of the listeners a hardly conceivable level of concentration, or call for long-drawn-out, complicated explanations. Here the new art-form could begin, by speaking directly to other faculties in the human being. Then these truths also would be understood.

The first practical exercise was given by Rudolf Steiner at once:

Tell your daughter to walk alliterations: a strong, somewhat stamped step on the alliterated consonants and a softer gesture when this consonant is lacking. She should remember that alliterations appeared only in the North, that is in lands where it is very windy. She should imagine an old bard, striding along the sea shore in a storm, his lyre in hand. Every step is a deed, is a battle and a victory over the storm. And then he plucks his strings and unites his song with the song of the storm.

From the Anatomical Atlas for Artists.

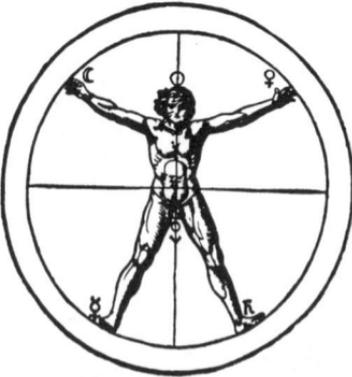

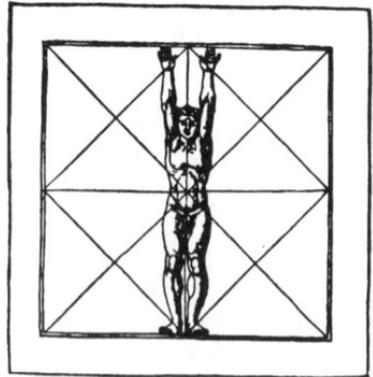

Drawings from The Occulta Philosophia *by Agrippa von Nettesheim, chapter XXVII.*

Through this conversation, occasioned by such a painful blow of destiny, new, brighter prospects gradually opened up for Clara and Lory Smits.

Clara returned to Düsseldorf. There followed weeks of most agreeable and earnest expectation. Rudolf Steiner was busy with lecture tours, but he suggested that the two women meet him in January 1912 in Kassel. There they had the opportunity of hearing lectures especially relevant to them.[16]

On 29 January Rudolf Steiner gave Lory her first lesson. Surprisingly, she was not asked to make a single movement, nor did she see even one gesture of the new, visible speech. Instead she was given the following instructions:

— learn to know the human body, especially the bones, joints, muscles and ligaments necessary for movement. It would be best to use the *Atlas of Anatomy for Artists*;
— look at Greek sculpture as much as possible—originals, copies or just reproductions. (She should never try to imitate the gestures, however);
— read as much as possible about Greek temple dances;
— speak sentences using only a single vowel and meanwhile observe exactly what happens in the throat. Then dance it;
— write with her feet, the left foot in mirror-writing;
— look for six drawings of the human being on a background of geometrical forms in the book *De philosophia occulta* by Agrippa von Nettesheim. Imitate these exactly, springing rapidly from one to the next;
— learn two circle dances. The first one: seven people walk slowly in a circle. Each of them is simultaneously being circled by a further person. The second one: a number of persons stand in a circle, opposite each other in pairs. They follow the form of a lemniscate to the opposite side, meeting in the middle. Each pair begins slightly later than the one before it, so that only one pair at a time is meeting.

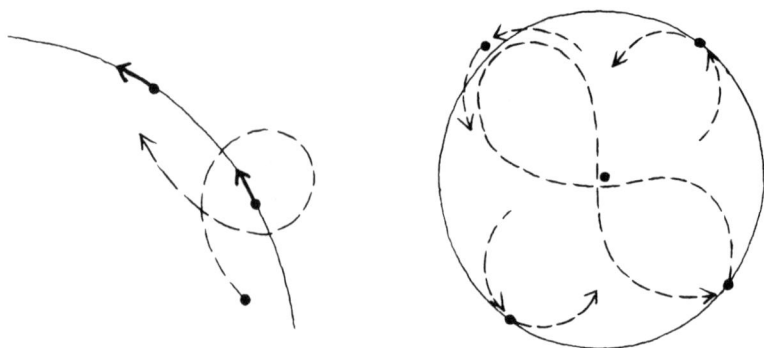

Then Rudolf Steiner opened a book. He showed us a reproduction of a figure which seemed most definitely Egyptian. It was Apollo or the 'Youth of Tenea', thus early archaic, but still strongly influenced by an older Egyptian period. Particularly the position of the feet was Egyptian. It was entirely earthbound, with the weight of the body carried evenly by both feet. This Rudolf Steiner pointed out to us as the essential aspect. He called it the 'purely human element', and 'if another impulse had not taken hold of humanity, we would have had to remain always on one spot, like plants. But then another impulse did take hold, causing us to revolt against such an earthbound existence.'

Now Rudolf Steiner showed us another figure, this one pure Greek. It was the Apollo Sauroktonos by Praxisteles, the 'killer of lizards'. Rudolf Steiner showed us how a different impulse had taken hold of the figure, and now the back foot had so freed itself from gravity through counteracting earthbound existence, that his whole weight was shifted onto the other foot, and he could now move freely.

'There you have the famous Greek standing-leg, which

actually comes about through the activity of the other foot, and which enables that foot to be moved in freedom from the earth.' After a short pause he said, smiling, 'So you see—not even in space is progress possible without Lucifer. For this other impulse is a luciferic one—which here however is fully justified.'

To continue Lory's training Rudolf Steiner suggested that she come in July to Munich, to the rehearsals of the mystery drama performances.

Clara and Lory Smits returned to Düsseldorf and energetically set to work, eagerly wondering what would arise out of these varying tasks. The largest room of the house lost its function as living room—everything was removed except the piano and some chairs, so that Lory could stamp alliterations against the storm and dance the special sentences. Then mother and daughter carefully planned the times for daily practice and study.

18 year-old Lory was full of hopeful expectation about her dancing, artistic future. But first she had to work through all of Rudolf Steiner's indications, which she had written down but never yet tried nor seen demonstrated—for six months all alone without encouragement or corrections. It strikes one as a time of inner testing.

She had a posture that was strikingly beautiful. She had a natural, encompassing gift for movement. And she wanted to move! Would she be able to take up these instructions imaginatively, with joy in this path of discovery? Would she be able to summon up the will, the patience and the perseverance for daily concentrated practice and theoretical study?

The degree to which Lory did actually acquire a sure knowledge of anatomy was shown many years later when she was a very old woman, and a young girl sprained her foot. Lory spoke of the functions and medical names of the bones and muscles just as they could be read in the doctor's report. At the age of 70 she was still performing the six positions of

Agrippa von Nettesheim quickly and exactly, *jumping* from one position to the next!

She wrote in 1950 about the exercise which had surprised her the most:

> I should do speech exercises. Speak sentences which had only one vowel, and observe exactly what was happening in my throat, and this I should then ... dance! As an example he wrote:

> 'Barbara sass stracks am Abhang'
> (Barbara's asked for sacks of salmon)[17]

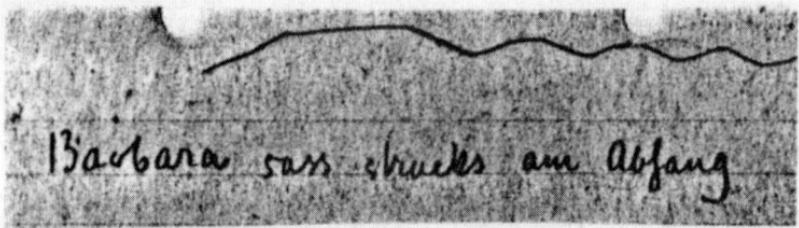

Rudolf Steiner's notebook. 29 January 1912.

I should think of other sentences using other vowels. He drew the line as he spoke the sentence once more, strongly emphasizing it and bringing out the 'Ah'-sound: 'Bar' is a jerk upwards, '-ba ra sass' are three drawn out sounds, especially the 'sass'. 'Stracks' is a jerk again, but this time downwards, and 'am Abhang' are wave-like movements. Yes, well, and then dance it! The eloquent Greek advice, 'Whoever has soft arms, let him dance' was not yet known to me, so I tried [...] to express these mainly dynamic experiences that I had in speaking the sentence [...] by walking, springing, hopping, dragging—but, frankly, mainly with the legs. With my arms and the rest of my body I merely gently indicated the upward or forward or downward motion.

GEGRÜNDET ZU NEW YORK 17. NOVEMBER MDCCCLXXV.

Die Theosophische Gesellschaft.

SATYÁN NASTI PARO DHARMAH

Hierdurch wird bezeugt, dass

Fräulein Lory Smits

zur Mitgliedschaft der THEOSOPHISCHEN GESELLSCHAFT zugelassen worden ist im
5. Monat ihres *19* Jahres.

1912 30/3. Eingetragen zu *Berlin* *Annie Besant*

Dr. Rudolf Steiner, Präsident der Theosophischen Gesellschaft.
General-Secretär.

Hauptquartier: Adyar, Madras, Indien.

Lory Smits' membership card for the Theosophical Society.
(March 30, 1912).

Lory became a member of the Theosophical Society on 30
March 1912. As a 19 year-old she could now attend Rudolf
Steiner's lectures everywhere. She heard two of his lectures in
Düsseldorf on 5 May 1912. The public one had the theme *The
Spiritual Guidance of Man*. To members he spoke on Bud-
dhism and Christianity. At the end of it he spoke again of the
Rose Cross motif which had made such a deep impression on
her five years before. He spoke of the deep religiousness of the
poet Anastasius Grün, who experienced this symbol in con-
nection with a distant future vision of peace on earth, quoting
the last verse of his poem 'Five Easters':

> So in the midst of splendour and fullness, stands
> the Cross on Golgotha: glorious, great with portent—
> hidden wholly under its robe of roses,
> a wealth of roses under which, long since,
> the Cross has vanished quite from view.[18]

Rudolf Steiner also gave a very succinct characterization of ancient Greek culture, which was to throw much light on Lory's studies of Greek art:

> Next we come to a culture which stood firmly on the earth: Graeco-Roman culture. There we see a clash between the wonderful merging of spirit and form in the Greek works of art [... and the fact that] the spiritual aspect of Greek culture is characterized by the words: 'Better to be a beggar in the upper world than a king in the realm of shadows.' Dread is expressed in this saying, dread of the world behind the physical world, dread of the world to which human beings are to go after death. Spirituality had reached its lowest point. From then on [...] humanity had need of an impulse which would turn it again towards the spiritual worlds.[19]

2.

1907–1913. Rudolf Steiner and Marie von Sivers endeavour to bring the artistic element to life in the Theosophical Society

It was a wonderful stroke of fate that Lory Smits could be summoned to Munich at this point. A short time before the lessons began in which she would receive, learn and practise a wealth of gestures and forms for developing the new art of movement, she had an all-encompassing experience of the new form of drama that had arisen out of Rudolf Steiner's conscious approach to supersensible processes in the human being. It was out of such knowledge of the supersensible aspects of the human being that he would also develop the new art of movement.

Years of preparation with Marie von Sivers had preceded the performances of the mystery dramas. These years will be briefly described here, for they provided a foundation and protective mantle for the development of the new art of movement, and for Lory Smits herself, which would later allow it to unfold and come into its own.

Marie von Sivers was not only a broadly educated and lively personality, she was an artist of high rank.

She had met Theosophy through Edouard Schuré and begun a correspondence with him, because she wanted to translate his play *Children of Lucifer*. In 1900, at his suggestion, she attended lectures at the Theosophical Library in Berlin. There Rudolf Steiner was speaking on *Mysticism at the Dawn of a New Age*. She realized that in contrast to the usual theosophical teachings based on ancient oriental spirituality, Rudolf Steiner's lectures also included western culture. When she heard him speak on *Christianity as Mystical Fact* in 1901, she recognized that he was an individual with the capacity to make the occult foundations of Christianity accessible to

humanity. She asked him whether this wasn't a necessity for spirituality in European culture. Rudolf Steiner affirmed this, telling her what possibilities he saw for making this kind of knowledge available, as well as developing a modern path of spiritual development. In order to help serve this lofty goal, Marie von Sivers took on the organizational work that his lecturing and writing required. From the start she demonstrated a style of work suited to the dignity of the task. For its sake she was prepared to set aside her own artistic intentions. Rudolf Steiner however encouraged her to cultivate them further. In his autobiography he wrote:

> Marie von Sivers was *the* individual whose entire being brought the possibility of keeping every slightest sectarian character out of what we did, giving it a character which placed it into cultural life in general. She was deeply interested in the arts of drama and recitation–declamation. She had received training at the best schools in Paris, which perfected her ability beautifully [...]
>
> It was important to Marie von Sivers and I to bring the artistic element to life within the Society. Spirit-knowledge as an experience gains existence in the *whole* human being. All of the soul forces are stimulated. The light of spirit-experience, when this experience is there, shines into the creative imagination.
>
> But here something enters which creates hindrances. The artist has a certain anxiety about this shining of the spirit-world into imagination. With regard to the activity of the supersensible world in his soul he wants to be unconscious. He is quite right to want this if we are talking of 'stimulation' of the imagination through the kind of consciousness which has dominated cultural life since the beginning of the consciousness age. This 'stimulation' through human intellectuality has a deadening effect on art.
>
> But just the opposite occurs when spiritual content which is really *perceived* irradiates imagination. Then all the for-

mative forces that ever led human beings to art are resur-
rected.

Marie von Sivers stood fully within the art of speech
formation; she had a most wonderful relationship to drama.
Thus a sphere of art was available for anthroposophical
work in which the fruitfulness of spirit vision could be
tested.[20]

Rudolf Steiner and Marie von Sivers carried out their artis-
tic initiatives unerringly. The series of première perfor-
mances began in 1907 in Munich with *The Sacred Drama of
Eleusis* by Edouard Schuré. This play portrays scenes from
the mysteries of pre-Christian times. There followed in 1909
the premiere performance of *Children of Lucifer*. Rudolf
Steiner wrote:

> The characters and action of this work of art arise from the
> spiritual streams of the fourth century after Christ. Using a
> particularly characteristic moment in human evolution,
> Schuré wanted to portray two basic impulses in the striving
> human being—firstly the experience of our divine origin;
> and secondly, our divine future.[21]

Marie von Sivers translated both dramas from the French and
played the main roles. Rudolf Steiner transposed them into
free rhythms and directed.

With his own mystery dramas Rudolf Steiner unveiled an
entirely modern, future-oriented culture of the mysteries. The
audience beheld soul dramas of people seeking spiritual
knowledge in the twentieth century. They saw the dangers, the
tests, the striving and the fulfilment. Since 1902 Rudolf Steiner
had laid the basis for understanding these dramas by com-
municating results from his spiritual research. For every
interested and unprejudiced person the way to understand
supersensible reality was now open: the connection of man's
soul-spiritual nature with his physical body; the events of birth
and death; reincarnation and karma; man's relationship with

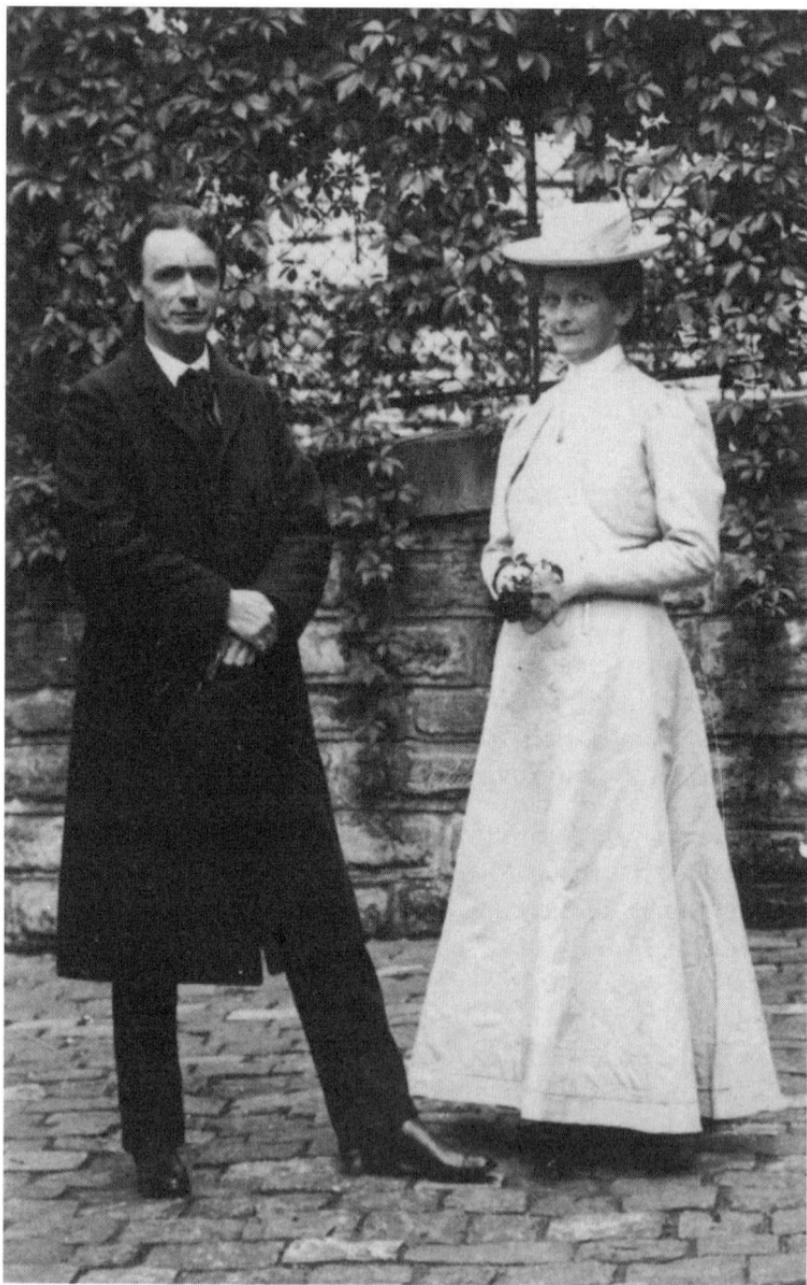

Rudolf Steiner and Marie [Steiner] von Sivers, 1908.

nature and with the invisible beings of the higher hierarchies; the development of consciousness from prehistoric times until today. He had pointed out two supersensible beings which can hinder human development by coaxing us into one-sidedness, so that we lose our equilibrium. These beings are Lucifer and Ahriman. Ahriman gives forces of stability and concentration to the soul. If this becomes too one-sided, then the soul tenses up to the point of obstinacy and fear. Lucifer brings forces of

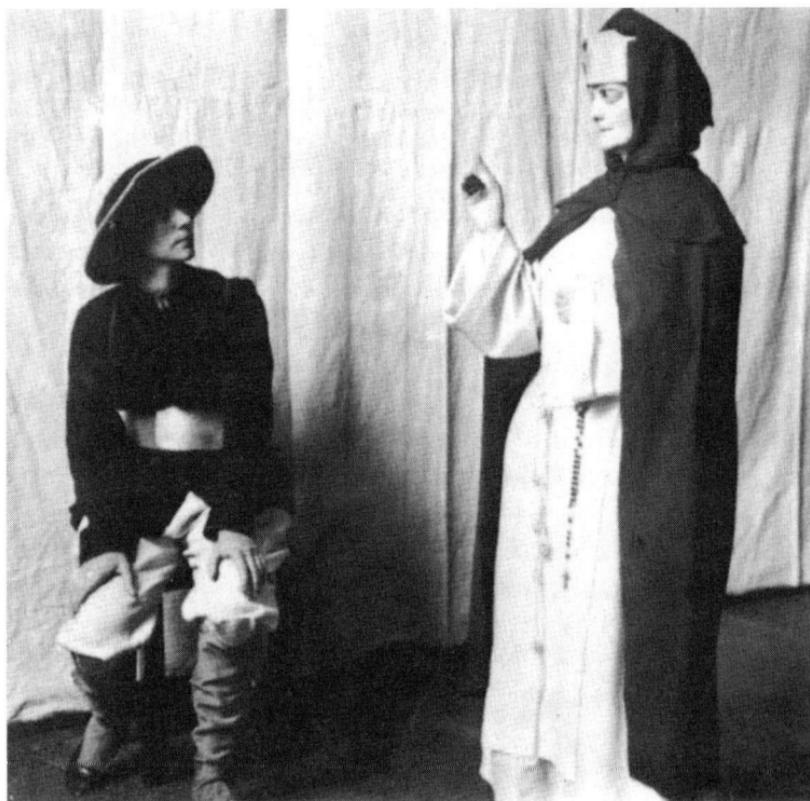

Marie von Sivers and Mieta Waller in the roles of the monk and the mining engineer Thomas, at the première in Munich of Rudolf Steiner's Mystery Drama The Soul's Probation.

lightness and freedom, but can seduce the soul into reckless-
ness and into losing itself.

Rudolf Steiner had outlined the conditions for seeking
higher knowledge, and Lory Smits, too, had heard him
speaking of these things. In artistic form in the mystery
dramas, the audience experienced what a *specific individual*
can encounter on the path of knowledge. Grappling with one's
own destiny, struggling for one's own free choices, is different
for each person. For the audience it was deeply moving to
witness such dramatic struggles.

The première of the first drama, *The Portal of Initiation*,
took place on 15 August 1910 in the theatre in Munich; *The
Soul's Probation* on 17 August 1911 and *The Guardian of the
Threshold* on 24 August 1912 in the Theater am Gärtnerplatz;
and *The Soul's Awakening* on 22 August 1913 in the Volks-
theater.

These performances were prepared in a few weeks. Rudolf
Steiner wrote down each scene only shortly before the first
read-through. He produced and directed, designed stage sets
and costumes, and rehearsed with individual participants.
Marie von Sivers took the main role, Maria.

Because of the sovereign competence of these two person-
alities, who determined the style of the performances, the main
impression was not amateurish even though only two pro-
fessional actors took part. The participants were able to live
into their roles because they had a deep interest in the inner
drama of the dialogue. Rudolf Steiner, as both author and
director, could form every last detail in a homogeneous way.
Some of those acting, helping or watching have written of the
experience. For many, those festive weeks were the high point
of their lives.

What a comprehensive preparation for the new art of
movement!

Lory Smits arrived in Munich at the end of July 1912, diving
straight into the midst of this artistic activity and rehearsal
atmosphere:

When I arrived I found a message waiting for me to say that I should be at the rehearsal room in a school gym at 9.30 the next morning. I was to be part of something amazing—something that caused huge surprise and [...] even indignation among those involved. 'Dancing' spiritual beings were to appear on stage! They were practising these dances when I first entered the hall.

This was a rehearsal of the sixth scene of *The Guardian of the Threshold*. One of the main characters, Capesius, a professor of history, is deep in thought. His soul lets go of his body. In several scenes, the audience is shown what Capesius perceives while in this state. The supersensible beings Lucifer and Ahriman appear, accompanied by the thought-beings belonging to them. The luciferic beings are seen on the left side of the stage, wearing dresses of red cinnabar, red chiffon stoles and reddish wigs. They move with elegant flowing lightness. The ahrimanic beings are on the right, and are wearing faded blue-grey dresses, stoles and wigs. Their movements are hard and jerky, as if they cannot free themselves from the heaviness of the earth.

Rudolf Steiner had assigned eight or nine people to each group, giving them very simple choreographic forms to follow. Lory Smits was assigned to the ahrimanic beings. The stage directions were:[22]

LUCIFER (speaking broadly, emphasizing every word):
Within thy will cosmic beings work.
(Beings approach from Lucifer's side which make dance-like movements portraying thought-forms corresponding to Lucifer's words.)
AHRIMAN (also speaking broadly, but in a course tone):
These cosmic beings, they bewilder thee.
(After these words, thought-beings move from Ahriman's side, making dance movements that correspond to his words. Then the movements of both groups are done simultaneously.)

LUCIFER:

Within thy feeling cosmic forces weave.

(The thought-beings on Lucifer's side now repeat their movements.)

AHRIMAN:

These cosmic forces, they seduce thee.

(The thought-beings on Ahriman's side repeat their movements, then both groups together.)

LUCIFER:

Within thy thinking cosmic thinking lives.

(Repetition of the movements by Lucifer's group.)

AHRIMAN:

These cosmic thoughts, they mislead thee.

(Repetition of the movement by Ahriman's group. Then the movements of each group are repeated four times separately and three times together.)

At the time that this scene was performed, Rudolf Steiner had not yet shown Lory Smits a single gesture or form for the new art. Yet this performance was a significant, appropriate debut. The task was to make visible, through movements and awakened inner soul forces, an invisible occurrence of the soul realm—which was also to be the task of the future art of movement. Also deeply characteristic was that this performance was part of a drama depicting how people of the twentieth century approach the threshold of the spiritual world. The new art of movement, too, would be significant for such people.

Lory Smits waited day after day for her lessons to begin:

...One day I met him in a doorway. Perhaps I looked at him very expectantly, in any case he put his hand on my shoulder and said: 'Yes, little one, the wisdom of the whole world is needed for it. I cannot tell you yet. Here during these weeks I cannot take the time I need for it. Would it be possible for you to come to Basel when I am there in September? There I will have time.'

Thus her five weeks in Munich were wholly devoted to the exceptional experiences of the performances and lectures, into which she plunged with all her being. Looking back on it later, she felt it to be a shining preparation which shed much light on the lessons which came later.

She saw *The Holy Drama of Eleusis* by Schuré on 18 August, then Rudolf Steiner's three mystery dramas: *The Portal of Initiation, The Soul's Probation* and *The Guardian of the Threshold* on 20, 22 and 24 August; the latter she was performing in, and so could take part in many rehearsals. She attended Rudolf Steiner's lectures from 25-31 August, *Initiation, Eternity and the Passing Moment.* Aspects of initiation were depicted in these lectures, which were therefore especially inspiring for the audience, encouragng them to concentrate their attention on soul-spiritual processes and to make themselves more independent of physical perceptions. Various motifs were mentioned which would be significant for Lory's coming lessons.

At the end of the lecture cycle Lory and Clara Smits were unexpectedly summoned by Rudolf Steiner after all. On this evening he gave them the first definite indications for the vowel-sounds

$$\text{I (ee) A (ah) O}^{23}$$

'Stand upright', he said, 'and try to feel a column from the balls of your feet to your head. Learn to feel this column, this uprightness, as I (ee).' While I was trying it he [repeated]: 'The weight rests on the balls of the feet, not on the heels . . .

Now shift this column so that your head is behind the point above your feet. This is the position that you should learn to feel as A (ah).

And now the third position: Bring the head-end of the column forward, so that it is in front of the foot-end, and learn to feel this as O.'

He gave only those three sounds, and only in that form—in other words, no arm movements as yet.

Lory and Clara Smits were able to spend the following days high up in the Swiss Alps at the farmhouse of a friend. Lory, accustomed to the breadths of the Rhine lowlands, was deeply moved by the overwhelming mountains and lakes, which she experienced in a great variety of weathers. She was filled with wonder, admiration and reverence.

From there they travelled slowly down, stopping at Lake Constance and Schaffhausen, arriving in Basel on 14 September.

3.
September 1912. Rudolf Steiner inaugurates eurythmy; Lory Smits is given nine lessons

Full of expectation, Lory and Clara Smits went to hear the first of 10 lectures which had been announced as *The Gospel of St Mark*.[24] On the following afternoons Rudolf Steiner would be giving Lory's lessons; each evening there would be a lecture. One secondary, literary theme, which took up a third of the first lecture, seems like a signpost pointing to the new art of movement.

The first lecture's main subject was to show that a tremendous turning point in the development of humanity had been brought about by the death and resurrection of Christ. Rudolf Steiner illustrated this with comparisons of individuals from pre-Christian and post-Christian epochs. He referred to the great Greek poet Homer, who lived circa 800 BC, saying, 'The better one gets to know Homer, the more one admires him'. There followed a detailed characterization of the Trojan hero Hector. 'Please look at this figure of Hector if you get the opportunity. [...] As Homer describes him, Hector shows great humanity.'

Next Rudolf Steiner spoke of the great Greek philosopher and knower of nature, Empedocles, who lived during the fifth pre-Christian century in Sicily. Steiner confirmed the legend that Empedocles had thrown himself into the volcano Etna, in order to unite himself totally with the forces of nature.

Not only was he the one who first spoke of the four elements—fire, water, air and earth (and of how everything which happens in the material world occurs according to principles of hate and love, which cause the four elements to

divide and mingle), but he also founded important institutions of state...

Rudolf Steiner had done research into the later incarnations of such individuals of antiquity. Thus he drew attention to Hamlet, the hero in Shakespeare's play, who, like Hector, had really lived as a prince in Denmark.

> The same soul lived in Hamlet that had lived in Hector. Just such a characteristic example in which there is a striking contrast in the soul's manifestation can make clear to us what actually happened during the interval. We behold an individual such as Hector in pre-Christian times. The mystery of Golgotha breaks through into the development of humanity, and a spark from it that enters the soul of Hector, causes the archetype of Hamlet to arise, whom Goethe described as a soul unable to cope with any situation, and for whom no situation is sufficient, one who has a task he cannot fulfil. One might ask: Why did Shakespeare express it in this way? He did not know why. But one who can look into these relationships by means of the science of the spirit knows what forces are behind it. A writer creates unconsciously. At first the figure which he is portraying appears before him. Then the whole individuality which belongs to it—of which he knows nothing—appears like a tableau. Why did Shakespeare clearly emphasize certain of Hamlet's characteristics, which perhaps no contemporary observer would have noticed? Because he saw them against the background of the epoch: he felt how different this soul had become through its transition from the old life into the new. Hamlet the doubter, the sceptic, who doesn't know how to cope with life—the wavering one—he was what had become of the unerring Hector.

Rudolf Steiner's thoroughness here in examining the creative forces of great writers (which could open up a new dimension for historians) shows that it was very important to him to

awaken in the listeners a sense for the spiritual background of a literary work. This would also come to be one of the most important things required of people who would devote themselves to the new art of movement.

Steiner continued:

Faust, too, is such a figure in literature [...] who leads us back to a real person. He lived in the sixteenth century. He was there, though not in the way that Goethe portrayed him. But why did Goethe portray him in that way? Goethe himself did not know why. But when he directed his gaze towards the Faust tradition, which he had already known from puppet-shows as a boy, he was affected by forces from which Faust derived, which were an earlier incarnation of Faust: Empedocles, the ancient Greek philosopher. All of that radiated into Goethe's figure of Faust. And one could say that the pre-Christian nature-mysticism of Empedocles throwing himself into Etna, uniting himself with the fire element of the earth, is transformed in a wonderful way in the closing tableau of Goethe's *Faust*. Faust's ascension into the fire element of heaven through Pater Seraphicus, etc! Slowly and gradually an entirely new spiritual direction united itself with the deeper striving of human beings. It began a long time ago already for the deeper spirits of humanity—without them knowing anything about reincarnation and karma: when they looked at a soul [...] which they wanted to portray out of the very depths of its inner life, then they portrayed what shone over from earlier incarnations. Just as Shakespeare portrayed Hamlet as we know him (although he had no idea that the same soul lived in Hector as in Hamlet), so also did Goethe portray Faust as if the soul of Empedocles with all its peculiarities stood behind it, because the soul of Empedocles really was part of Faust. But this is characteristic of the progress and evolution of the human race.

Sixteen months later Lory Smits, and others trained by her,

performed part of this scene at the General Meeting of the Anthroposophical Society.

After this first lecture Rudolf Steiner asked the Smits ladies to come to Bottmingen the next afternoon. Bottmingen was a rural suburb south of Basel. Each day, now, they walked through colourful autumn trees and rustling leaves along a little stream to the house where Rudolf Steiner was staying. He received them in a tiny room on the ground floor. In it were only a sofa, a table and some chairs.

There were nine lessons. Rudolf Steiner described the very first, seed-like principles and forms of an art of movement that did not yet exist. It was simultaneously a training for a career that 'should arise from the anthroposophical movement'. Lory Smits was 19.

It was the only training which Rudolf Steiner himself carried out. The exceptional configurations of destiny made it unique. Yet its methods were developed in such a living way, out of the archetype of human speech, that for many generations to come it provided guidelines for teaching.

During these nine days Rudolf Steiner gave a wealth of indications for a totally new kind of movement arising out of human speech and poetry:

— *Gestures* for vowels and consonants;
— *movements* for poetic rhythms;
— principles for developing *grammatical elements* in space (e.g. *I—you—he—we—you—they*);
— and, not least: a basis for letting the *deeper meaning* of a poetic work flow into movement. How thinking, feeling or willing become visible; which *soul mood*, for example, (seriousness, sadness, amusement, tenderness, etc.) is being expressed.

Lory would never have been able to absorb this abundance in just nine sessions, if she had not had a special capacity for it.

Her later friend and colleague, Elisabeth Baumann-Dollfus, wrote:

> She was not a scientifically inclined person, also not some-
> one who could have worked in an office or business firm.
> Her whole being turned towards expression and activity in
> movement; in dance, or in gymnastics [...] with her slim
> supple body and her sparkling nature she appeared as if
> predestined for this career.

Lory's free, upright stance reminded one of early Greek art. Her natural mobility had not yet been influenced by formal gymnastics or dance lessons. She had a gift for music, speech and literature. German, including contemporary literature, had been especially cultivated at the private school where she had been taught. (She had a special interest in the poetry of the controversial Friedrich Nietzsche. As a 15 year-old she had attended a lecture by Steiner, 'Friedrich Nietzsche in the Light of Spiritual Science').[25]

Above all, however, Lory was utterly open to the new, anthroposophical form of movement which was seeking a way into twentieth-century cultural life. Before her first lesson she had already heard more than 30 of Steiner's lectures. Without reflecting on it a great deal she had trustingly followed his directions from the preparatory lesson in Kassel. Only years later did it begin to dawn on her how appropriate those directions had been, and how much skill she had acquired right from the beginning.

After a brief, warm greeting—and without referring to his earlier indications—Rudolf Steiner began by saying that this new art of movement could only be done by someone who recognized and was convinced that the human being consists of body, soul and spirit. He introduced the actual movements with the exhortation:

> You must learn to acquire a subtle, differentiated feeling for

the individual sounds. And for this you must learn to let your heart rise up into your head. [. . .] First your heart must speak; later your head.

He immediately began to show her the vowel gestures. Each instruction was introduced with the words: 'Learn to feel'— and this exhortation meant simultaneously: feel the soul-force from which the characteristics of a spoken sound arise, *and* the sensitive perception of your own movement while doing the sound in eurythmy. One's feeling and awareness were directed towards this correspondence between the arm movements and the soul nuance of the sound.

> . . . learn to feel 'A' (ah) as a gesture of warding something off, and express it by bending the hands backwards and upwards. [Or for the sound 'O':] every joining and round-ing of the limbs, together with the feeling of lovingly embracing.

Often he revealed a wealth of variations, as with the sound 'I' (ee):

> Every extending motion, wherever you experience it, whether in the arms, the legs, or in the whole body as I already told you in Munich, but also in your glance; or with your nose, your tongue, or only one finger; or, if you can, with only a toe. But it must be the experience of stretching and extending. A highly typical 'I' (ee) is to stretch one arm upwards to the side and the other one correspondingly downwards.

After Rudolf Steiner had introduced the single vowels and nearly all of the diphthongs in this way, 'he gave indications about how to practise: Undertake each sound individually again and again, try to find ever new movements, and don't rest until every movement, even the smallest, is really experi-enced and felt in the heart. Only then should one try to put two sounds together.'

Then he picked up a large pencil, holding it at first casually, as if accidentally.

'This is V. Learn to feel V as having something in the hand, or touching it only.' Next he guided his hand so that the tip of the pencil pointed to his chest and said: 'Learn to feel B as having something in your hand which works back onto your body.' And as the third movement he used the pencil like an extension of his finger and pointed it forwards with an energetic, raying, gesture: 'Learn to experience S like this. S always entails moving or forming with an object. The archetype of S is the man leaning on a thyrsus-rod.'

When Lory began to write down her memories in 1950 she found she could sum up what happened in a new way:

Rudolf Steiner described the whole sphere of the vowels, showed how the soul expresses its deepest being: it is seized by strangeness and amazement, experiences itself in bright self-awareness, inclines in loving admiration. He then set against it three consonants. The difference could not have been more striking. It is as though he puts a piece of the outer world into our hand—and everything that came before is as if extinguished; our whole attention is directed at this piece of the outer world! We have to conform to it, devote ourselves to a completely different activity—imitating, reproducing what is outside us.

We have to develop warmth of feeling and inner truthfulness when we do vowels. We have to be skilled, imaginative, resourceful when we do consonants.

Rudolf Steiner's evening lecture after this lesson concentrated entirely on the Gospel of St Mark. But, heightening the secondary theme of the previous evening, he now showed how instructive it can be, when reading the Bible, not to see the descriptive events as arbitrary or accidental, but to discover their magnificent artistic-dramatic composition. People will need to learn to read the Bible in a new way:

When they begin to grasp the fact that it is permeated by a dramatic-artistic quality, in contrast to the sweet sentimental way it has been seen until now, then the Bible will, of itself, become something to inspire religious devotion. Art will become religion through the Bible.

Discovering spiritual content in great works of literature, which often is expressed more clearly through artistic form than through content, would also become a task for those who would devote themselves to the new art of movement.

The second lesson was devoted to the gestures of the consonants. It will be given here as Lory Smits gave it in 1951, only slightly condensed. From the way she wrote and spoke of it, one can feel that this lesson made an especially deep impression on her. Rudolf Steiner described scenes of nature which he wanted Lory to imagine vividly: A peaceful evening landscape; the sun is setting behind gently rolling hills. White clouds hang motionless in the sky. A brook runs quietly through the meadows, trees are bending over it, flowers are blooming beside it. In the distance a solitary man is still working steadily and unhurriedly. 'And you are walking here, enveloped in the same peace, aware of every detail, responding to each with a gesture that breathes the same quiet and consistency: This through you, you sun—this through you, you hill, you cloud, you flower, you person. I [. . .] become part of you, part of the same peace, breathing the same stillness.' (*'Dies durch dich, du Sonne—dies durch dich, du Hügel, du Wolke, du Blume, du Mensch.'*)

'**D**—reaction to an external influence which is still.' 'This through you' (*Dies durch dich*). Here Rudolf Steiner moved his hands infinitely gently, several times, in a downwards motion. They sank down like autumn leaves [. . .] as if carried by the air; quietly sinking down and as if to indicate one single thing: 'This through you' (*Dies durch dich*). [English 'sound approximation': *day's door is deep.*]

Suddenly 'a strong wind rises up [...] everything is changed. The clouds are swept [swiftly onwards, changing] in form and colour. [...] The brook tosses up waves; it murmurs an exhortation and greeting. The trees are shaken by the wind, grass and flowers are pressed to the earth. A gust of wind tears my hat from my head.' The man is gesturing to me! Should I look for shelter under the trees or follow the man to his house? Or should I 'face the storm? Questions, stimulus, demands press upon me. [...] I have to react: **F**—reaction to demanding influence'—(*Für frohe Feste*). [English 'sound approximation': *fury for fester*.]

Rudolf Steiner demonstrated this movement several times also. [...] with an energetic, elastic movement his hands bounced downwards from above, 'and also his feet stamped briefly and firmly on the ground.'

Now 'another picture of a quiet outer world, but one that arouses aversion and disgust. The ruins of a cellar vault [...] water is dripping, owls and bats are whirring, the slippery floor is covered with worms. [We enter] carefully, hesitatingly, uneasily' Don't attract the attention of that animal! We try with a gesture of pushing away to raise a wall between ourselves and this outer world—at least to create a small area of cleanliness: '**G**—warding-off reaction.' ('*Genug gierig genießen, ganz gerne gehen*'.) [English 'sound approximation': *genus greedily go on knees, to grab greengages.*]

Now we are attacked after all! Over there a frog is getting ready to spring, here a snake is slithering towards us. [...] Our warding-off becomes stronger, more definite: '**K**—warding-off reaction.' ('*Kaum kräftig können.*') [English 'sound approximation': *Come Crafty Cannon*. K relates to G as F relates to D.]

But suddenly it gets really dangerous. Everything assaults us. We have to save our skin: '**H**—defensive, rejecting reaction.' ('*Hier heulen heute Hyänen.*') [English 'sound approximation': *here howl hot hyenas.*]

This first group D—F—G—K—H has a calming effect. It

'expresses a definite outside world. We react to it, but remain unchanged in our being. We ward off what might unsettle us [...] with G—K—H.' We accept beauty with D and F.

Rudolf Steiner summed up a second group, L—M—N—P—Q, as a 'stimulating' sequence:

L — becoming aware of the ability to freely unfold
M — feeling oneself within something
N — fleetingly united, a brief touch
P — enveloping oneself while entering
Q — painful reaction

'Becoming aware of the free ability to unfold' means to become aware of and connect oneself in imitation with all becoming, creating and forming in nature. It means experiencing the sprouting, growing, blossoming, bearing fruit, wilting and dying of the plant world [...] but also imitating the looming, towering, swelling forms in mountain and valley; feeling one's way into air and light. [...] What flexibility and nuances does the soul receive through L?

'M—feeling oneself within something', going through wind, mist, water, warmth, coolness. Each time it is a different experience.

By contrast, with N one only touches fleetingly, and withdraws again to the next thing. (*Nippen ... necken ... nicht, nein*'.) [English 'sound approximation': *nip in ... necking ... night, nine*.]

'P—feeling oneself to be enveloped.' Rudolf Steiner demonstrated it: 'While sitting, he reached down with both hands and drew around himself a wealth of colour and light, like a mantle of stars. It was an inimitable gesture full of dignity and grandeur.

'Of Q he only mentioned that it should be used sparingly, like dissonance in music.'

Finally he spoke about R, whose relationship to the calming

and exciting sounds he described as 'neutral, but reinforcing.' It can be done at the end of the calming sequence (which can help nervous people to ward off everything which is unsettling them); and also at the end of the exciting sequence (which can have an enlivening effect on inactive people).

R reinforces the therapeutic effect.

R—*being swept along by the wind*; where the step becomes a run.

Then he recommended that Lory actually look for these consonants outside in nature, in order to form them from her experience. 'Let yourself be carried away by the wind! Slip into the branches of a tree tossed by the wind, and feel what it is like!'

'Try to feel your way through deep mist or darkness in M, or try to experience the difference between sun and shadow with it. [. . .] Try forming a P when you enter a forest!'

When Lory was writing down her memories, she was aware of the wealth of indications which Rudolf Steiner had later given, and wrote: 'In the first two lessons Rudolf Steiner revealed with clarity and precision—though in a way that was fitting for my youthful feeling and understanding—the two basic themes which manifest everywhere in the marvel and wonder of this new art:

> Vowels and consonants:
> Behold thyself, behold the world.
> We seek the soul—the spirit radiates towards us:
> Planets and Zodiac.

In the 12 years that followed, Rudolf Steiner elaborated on the characterization of the sounds, describing them from other points of view.

In the evening lecture after this second lesson, the nature moods that had been conjured up so forcefully and vivdly in the afternoon, appeared again on a higher level. Rudolf Steiner described the prophet Elias, whose being was so powerful

that it exceeded the capacity of human embodiment, and was also able to work outside the body.

> He was too great [. . .] to be able to dwell totally within the soul of his earthly form. [. . .] He hovered around it [. . .] as if in a cloud [. . .] he went about the whole land like an element of nature, working in rain and sunshine. This becomes obvious if we look at the whole description, beginning with the domination of dryness and drought and with how this and everything which was needed in the land was helped by the way Elias formed and ordered his relation to the godly-spiritual world. His working was like an element of nature, like a law of nature. And I would say that the best way to get to know what worked in the spirit of Elias is to live with the 104th Psalm, with its description of Jahve or Jehovah as the god of nature who is working in everything.

The mood of the 104th Psalm harmonizes wonderfully with the mood of the nature descriptions of the afternoon's lesson. There it says (and we can well imagine that for this lecture cycle Clara Smits had the Bible in her luggage and that she read to her daughter from it):

> Praise the Lord, my soul! Lord, my God, you are magnificent, your garment is light [. . .] you spread out the heavens like a carpet [. . .] you travel on clouds as if on a wagon and you walk on the wings of the wind [. . .] you have made the earth firm. [. . .] You cause springs to gurgle in the hollows, water to flow between the mountains, that all the animals of the fields quench [. . .] their thirst. [. . .] You moisten the mountains and make the land full of fruit. [. . .] You have made the moon to divide the year; the sun knows its setting. You make darkness, so that it becomes night; then the wild animals are active, the lions roar after prey and seek their food. But when the sun rises, they rise up and go away [. . .] to their caves. Then man goes out to his work and his farming until evening.[26]

Marie von Sivers was present at the lessons from the third day onwards. Rudolf Steiner brought with him a book: Albert Czerwinski's *Anthology of Dance*. Lory should read about the dances of the ancient Egyptians, Jews, Romans and Greeks and write it down. He pointed out an illustration of a Corybant dance, in which the two men with their shields were making a gesture which corresponds to B.

Then he showed how the power of feeling which stands behind the arm gestures for the sounds can also be active in forms to be walked in space.

Not only forming sounds with your arms and hands is a possibility; you must learn to experience movement in space as well. And a straight line striving in any direction is just as much an 'I' (ee) as the extension of a limb. A second line moving at an angle to it is to be felt an 'E' (ay). Just extend both lines beyond the angle; then you see the 'E' (ay) with your eyes. And the third line, which closes the equilateral triangle, in that it returns to the starting point, is to be felt as 'U' (oo). Walking backwards is like going upwards towards something. So you should carry this equilateral triangle I E U (ee, ay, oo) within you as something archetypal.

Starting from this archetypal triangle—developed out of human speech and walked in space—Rudolf Steiner recreated for them something that had taken place secretly in the holy places of the Dionysian mysteries: an ancient dance. The three individuals present were well prepared for such an experience. They had seen the performance of *The Holy Drama of Eleusis*, which is a depiction of the mysteries, four weeks earlier. They had heard Rudolf Steiner's characterization of the gods Demeter, Persephone and Dionysus. Now he gave a detailed description of two polar opposite mystery dances. Each was based on the archetypal triangle which arises from the sounds I E U (ee, ay, oo).

The first dance was to fire a group of warriors with the

desire to attack, giving them courage for the coming battle. The Dionysus priest led the warriors into a circle. He himself took his place at the centre. The warriors planted their thyrsus rods in the earth well in front of them. The priest called out with a strong rhythmic accent: 'I I E U U' (ee ee ay oo oo), and the men danced an acute-angled triangle whose base was the radius of the circle.

When the men came back successful from the battle, still charged with excitement, they put down their weapons, took the thyrsus rods, and placed them in the earth. In order to calm them and bring them into a peaceful mood, the call of the priest was now 'I E E U' (ee ay ay oo), and they danced an obtuse triangle along the periphery of the circle (see drawing on page 73).

Rudolf Steiner called out the vowels of the priest with a full voice and he tapped the rhythm (uu—short, short, long) clearly with a pencil on the table, gradually making it louder and faster:

> He called the first dance an 'energy' dance. He said that today, too, the dance could give people strength for carrying out a shared task (for example children or teachers). And by means of the second dance, the 'peace' dance, the most quarrelsome children would become peaceful and content together, and the most difficult young people could become the mildest of married couples. 'If one could only get them to do it!'

Lory Smits was deeply impressed. 'We, however, who were allowed to hear all this, experienced with wonder: there is a place after all where the ancient temple dances can be revealed today.'

She herself had found out how hidden the knowledge of the mysteries had been already in Greece, and had remained so until our own times. For when she had looked for sources in literature about the ancient Greek temple dances she had found disappointingly little. Later she wrote,

...in looking for Greek literature I came across the following formulation in 'Pantomime',[27] by Lucian: '...one cannot find a single consecration which does without dance'; and '...it was said of people who betrayed the mysteries: they danced them in public.' That brought my search for information about the temple dances to a rather emphatic conclusion.

Lory fared very differently with Rudolf Steiner's suggestion to look at Greek sculpture, but not imitate it. 40 years afterwards she wrote

In the face of this godly beauty—stillness and yet flowing movement were expressed in it—I felt my own body in a new way. There lit up in me a feeling of permitted, god-intended, being-at-home in my own body. I could close my eyes even and still feel how my breathing was different, how my blood flowed and pulsed differently. I felt like a plant which had been standing wilted and limp in the heat without water [...] which now was watered and could fill itself with new life right into the tiniest leaves and fibrils. Could it have been a very tender, as yet unrecognised perception of my etheric body by way of these works of art which give us evidence of a time when the etheric and physical body experienced their most beautiful and harmonious interpenetration? A time in which this etheric could grasp a physique which was still malleable and transparent, and which therefore could let the etheric laws be revealed? But we are no longer Greeks; our physical body has become harder and heavier; our etheric body is imprisoned in it and invisible. Therefore nothing essential could be achieved by imitating the gestures and movements of Greek art, however faithfully. We must learn to experience this etheric body as a supersensible member of our being; it is at home in the last, the lowest heaven, showing the way to the higher heaven from which it has come down...

With the 'energy' and 'peace' dances Rudolf Steiner revived a
practice of ancient mystery wisdom. But it was clear from the
tasks he had given Lory that he wanted her to be familiar with
the historically available traditions. For when the mystery
centres had fulfilled their task and come to an end, their
spirituality flowed into public cultural life. Sculptors created
the wonderful, seemingly ensouled statues of classical times.
Poets transformed the rhythmic forms of the cult dances into
the rhythms of literature. Rising rhythms from dances in the
temple of Dionysus can be found in ancient Greek tragedy: at
the beginning of the performances, the choir entered the stage
in a half-circle with an anapestic rhythm (∪ ∪ —). The actors
spoke in six-footed iambs (∪ — ∪ — ∪ — ∪ — ∪ — ∪ —). The
iambic element was so appropriate for dramatic content, and
it had such strength, that it was later taken up by the romance
and germanic languages. Shakespeare, Molière, Goethe,
Schiller and many others wrote their dramas in iambic verse.
Rudolf Steiner's mystery dramas, too, were written in free
iambic verse.

Lory had found little information about temple dances in
ancient Greek literature, but in searching she had acquired a
good knowledge of Greek mythology and Greek metrics. Thus
she could give a quick and sure reply when Rudolf Steiner
asked her what rhythm he had been tapping for the 'energy'
and 'peace' dances: anapest! Rudolf Steiner could go directly
on to the essentials: he gave her suggestions for how these
rhythms can be transformed into rhythms of the whole body.
He even made a suggestion as to how she could teach this to
her future students.

Fortunately this question gave me the opportunity of telling
him that I had come across the book *Dramatische Orchestrik
der Hellenen*[28] (dramatic orchestration of the Hellenes) by
Christian Kirchhoff. Kirchhoff had come to the conclusion
that the Greeks didn't need to write down a doctrine of dance
because they read all their movements from the text. He

referred to various rhythms, especially to rising and falling metres [. . .] and he showed that each god had been called in his own rhythm, etc. Rudolf Steiner responded, 'All that is fine and you can absolutely accept it as it is. But what is essential for a rising rhythm (and the iamb is the prototype of rising rhythms) is really that the iamb can be traced back to javelin throwing. It means reaching a clearly marked goal in the outer world, by the shortest means. One can feel the iamb to be like a jump out into life. And the falling rhythms, the trochee? The Greeks also called it the Mercury step. The messenger of the gods comes down to human beings on earth, but behind him is the wealth of godly wisdom and grace. And from this wealth he brings men joy and pain, tasks and disappointments—as the gods measure them out. Driven by this wealth, he plunges down with such vehemence towards the earth, that he has to cushion his fall. This is how the powerful long, and the short—which cushions his all too great momentum—arise. Often the Greeks even portrayed him limping. Demonstrate this later for your students! Take a rod and show how resolutely it drives forward into space, and show (perhaps by springing into the room from a chair) that you need the cushioning of the short. Experience it yourself, and try to teach your students how the iamb leads one brightly and courageously out into the world, but that the trochee drives man forward by an impulse of destiny, which dwells behind him in the spiritual world.'

With these last remarks Rudolf Steiner directed the gaze of his listeners away from the past, towards the higher forces within us, which always have and always will spur us on to take up the 'impulse of destiny which dwells behind us in the spiritual world' and to achieve 'a clearly marked goal, by the shortest means.'

During the entire lesson Lory did not perform a single movement of the metric rhythms; no anapestic steps in the 'energy' and 'peace' dances, no iambic or trochaic verses.

Rudolf Steiner introduced it all in such a way that the differentiated feeling she had developed since the preparatory lesson could unfold within her, without influence from outside, without an audience. The further task, of 'letting her heart rise up into her head'—namely to make her feeling-experience conscious enough to be able to transform it into physical movement—was left to her initiative as well.

This method is wholly appropriate for a person of the twentieth century.

Rudolf Steiner began the fourth lesson by drawing a Dionysian dance. The dancers should move from the periphery of the circle towards the centre (where the Dionysian priest originally stood). These movements were influenced not by sounds only, but by whole words. First meeting and separating ('I and you, you and I') we then joyfully approach the centre of the circle together ('are we').

Then Rudolf Steiner introduced a new motif: instead of making movements for the sounds of speech, the arms and body should take on positions filled with soul, to express moods: to express, for example, a mood which weaves through a whole poem, but which is only briefly indicated by a particular word. These are the gestures that Rudolf Steiner called: loveable; solemn; clever; serious; sad; happy; tender [or inward]; lightness. For Lory, the endless possibilities for varying individual sounds against the background of these moods was to become a source of deep satisfaction. (e.g. 'A' (ah), 'O' or 'I' (ee) in a sad, solemn or tender mood).

At the end of this lesson Rudolf Steiner surprised them with an exercise for promoting good posture and health—the first rod exercise. Lory should acquire a copper rod or wrap copper around a wooden one. Rudolf Steiner wrote down for her: 'rod down—rod up—rod to the right, vertical, right hand above—rod to the left, vertical, left hand above—rod r. v.—rod up—rod down.' This was to be done with absolutely 'straight arms, and the side movements were neither to stray

above shoulder level nor towards the middle'. The best would be to practise it seven times in a row, and always with precision—otherwise the intended effect on the muscles of the back will be illusory!

At the fifth lesson Rudolf Steiner drew further forms.

> In every form which on the way back again touches all the points it passed through originally, the soul expresses itself as an ego [...] It need not be a straight line, but it must repeat itself in returning. This is essential.
>
> ... Every form which on the way back touches even just one of the original points, speaks to a 'you'.
>
> Every form that does not touch itself again, but does return to the point of departure expresses he, they, it, the being of Dionysus, the being of the goddess Nature, or the being of the universe and everything in it...

When Lory began to put these indications into practice in the weeks that followed, she was delighted with all the surprising ideas for artistic elaboration which the personal pronouns opened up for her.

> It is truly fascinating to look at lyric poetry from this point of view—so many poems can be portrayed very satisfyingly in this way. Are they not an expression of every relationship that the soul has to itself, or to a 'you', or to the merely seen, revered, or feared third person, 'he'?

Rudolf Steiner drew many variations of 'you' forms, especially 'you' forms to be done together in a circle.

> They should be done to texts which are spoken together, and which have a general human content, for these 'you' forms express the feeling of all of humanity. The verse he wrote down was meant as an example, but he added the strict requirement that it be brought into an anapestic rhythm...

Lory Smits reports that she had to practise this for weeks because it was so difficult. The verse was:

> Boldness, when it's united with wisdom,
> Brings blessing upon you.
> But when it acts on its own,
> Ruin will tread on its heels.[29]

The metre tends to have a dactylic character, that is why it was so hard to do anapestic steps to it.

On the sixth day Rudolf Steiner drew forms which can make visible the soul activities of willing, thinking and feeling.

> Every curved line, whether a position [...] or a movement, combined with directing the countenance straight ahead, expresses will.
>
> Every angle, combined with turning the countenance downwards, expresses thinking.
>
> Every mixture of straight and curved lines, combined with turning the countenance upwards, expresses feeling.

He gave several variations for these head positions. Rudolf Steiner developed the exercise of 'contraction and expansion' out of the relationship of the human ego to its surroundings, through 'laughing and crying'. This seemingly very simple exercise came to mean a great deal to Lory:

> For it offered the first indication of how one can deliberately colour one's movements, towards laughing, expanding, letting go, on up to the brightest light—or towards crying, contracting, closing oneself off to the point of the most hopeless blackness.

The seventh lesson took place on the clear autumn morning of Sunday 22 September 1912. It was a sacred hour. The new horizons which this art would be able to open up were glimpsed for the first time.

> 'Do an "H" once and then immediately an "A" (ah). Now do "L" seven times, then an "E" (ay). There follow three large, quiet L-movements, which lead to a great, long-lasting "U" (oo). At the end form a strong "I" (ee) and "A"

(ah).' Then he said gravely, 'Now you have done the word
Hallelujah . . . It means: "I purify myself of everything which
prevents me from beholding the Highest." '

This was the first word to be made visible in eurythmy. The
second word, also during this Sunday lesson, was *Evoe*.

The motif for the evening lecture was the transfiguration of
Christ in the ninth chapter of the Gospel of St Mark.

Lory said very little about the following lesson, which,
together with the first part of the ninth lesson, was devoted to
'serpentine dances' (later known as spirals).

At the ninth and last lesson Lory Smits was allowed to ask
questions. She asked what poem she should work with, once
she had practised the sounds and sound-connections long
enough. Steiner's immediate reply was:

Ocean Stillness,[30] by Goethe. There you have a poem which
you should do with vowels only, there is nothing of the
outside world in it at all. It is the depiction of a state of
trance, a state which occurs entirely within the soul, neither
disturbed nor coloured by the outside world. But immedi-
ately following you should do the next one: *Happy Jour-
ney*.[31] This is entirely to do with experience of the outer
world, therefore you should do it with *all* the consonants
(the word 'Äolus' should be done with *all* the sounds). But
these two poems belong together. Only together do they
make a whole.

He also recommended that she work with poems both in
vowels and consonants (an especially good example for this
would be Goethe's *Prometheus*)[32]: the vowels express Pro-
metheus' drive for freedom and his anger at the gods; the
consonants let the pictures arise—the rushing cloud, the lad
knocking the heads off thistles, etc.

Lory asked about 'W' (v), 'T', Ü (as in h**u**ge) and Ö (œ),
which had not yet been mentioned, and received suggestions
for them.

And then, at the last lesson in Bottmingen, in September 1912, the new art received its name. Rudolf Steiner said somewhat thoughtfully, 'We still need to find a name for what we have been doing', and Marie von Sivers, without hesitation, uttered as a matter of course the word '*Eurythmy*'—to which Rudolf Steiner most warmly agreed.

4.

September 1912–April 1913. Lory Smits independently works through the indications she has received and prepares the first performance

Early on the morning of 25 September 1912, the Smits set off for Düsseldorf. On the way they made a detailed plan for Lory's work. Since coming to Munich in July, they had received a wealth of impressions and inspirations. Now they were looking towards the future. Lory approached the task before her—transforming all Rudolf Steiner's indications into visible reality—with strength and vitality of feeling.

In the early mornings 19 year-old Lory worked alone. She kept exactly to the sequence in which her directions had been given. When one exercise had reached a certain level of perfection, she went on to the next, but she repeated the earlier one at least once a day. Thus she began each day with the I (ee) A (ah) O exercise that she had received in Munich. In the afternoons she taught her first students: her three younger sisters Ada, Ellen and Thea, and a boy who was living in the house. They were between 8 and 14 years old and could only report for lessons (which they did with more or less enthusiasm) after finishing their school work. Lory prepared these lessons during the late mornings. She meticulously drew what she was going to teach, practising it herself. She looked for appropriate poems and music for the rhythms and dances. A music-student friend was found to compose appropriate music for expansion and contraction, rod exercises and various kinds of steps. She discussed her plans with her mother, who played the piano and recited the poems during the children's lessons, simultaneously keeping a firm grip on the course of events. Once a week a few members of the Theosophical Society came

for a lesson. Sometimes others watched, showing a growing interest in eurythmy. Lory felt the ensuing conversations to be stimulating and helpful.

When she had practised sounds and sound-connections for weeks she felt it was time to start work on the two poems. She decided on a simple choreography made up of straight and curved lines for *Ocean Stillness*, and she tried to unite each vowel with the steps of the trochaic metre. When she came to the word 'bekümmert' (uneasy) she realized that she had not yet received an arm gesture for the sound Ü. Rudolf Steiner had merely drawn two parallel lines in two directions with the words: 'Ü—dancing past one another.'

At first she was at a loss.

How should I do it? There was no one to 'dance past one another' with! I would have to discover an arm movement that was adequate! And I would have to do it alone. Rudolf Steiner was far away and could not be asked. And it did get found, after intoning U Ü U Ü for a long time; and in April 1913 [the gesture I had found] was accepted by Rudolf Steiner as a matter of course. In the second poem, *Happy Journey*, several words turned up with SCH (sh) in them:

> Es rührt sich der Schiffer.
> Geschwinde! Geschwinde!...
> Schon seh ich das Land!

A clear S movement didn't satisfy me. SH would need to look broader, fuller, more blurred, less sharp—and it did! The movement came to my arms almost of itself. Otherwise *Happy Journey* was awfully difficult! There was so much to bear in mind! The R had to be worked into the rhythm, and right at the beginning came 'zer-reißen'—a short syllable ending in R, followed by a long syllable beginning with R! [...] I experienced and learned a great deal from this poem—also discouragement and depression. Yet help, too! When I just could not go on anymore, I would suddenly

hear the expectant tone of Rudolf Steiner's voice, and see his far-away gaze in Bottmingen as he said, 'You will see how beautiful that will be—what a differentiated feeling will be expressed!' Then all my enthusiasm came back again, and with fresh courage I attempted even the hardest parts!

Lory has to be admired for the way in which she coped with being totally on her own. She worked tirelessly, tackled the problems again and again afresh, and did not let herself be diverted from the goal. A good basis for this work was provided by her gift for movement, her freedom from prejudice, and her trust in everything that came from Rudolf Steiner. And Rudolf Steiner's belief in her—that she would be able to do it—was a bright guiding star. Her mother's strict and consequential but also loving assistance protected her, yet also left her free. However, her success in unfolding and developing Rudolf Steiner's seed-like indications was due above all to her ability to develop the kind of tireless practice which is suited to eurythmy: practising as one would a virtue, initiating all one's work daily and hourly out of one's best soul forces.

Six weeks before the long-desired day when Rudolf Steiner would come to see what she had done, Annemarie Donath arrived. The hard, lonely mornings were over now; now they could joyfully collaborate; this enriched and deepened the work.

Annemarie Donath had been in Munich in 1912. She would have liked to attend the mystery dramas, but her mother thought it better to distract her from these 'much too serious things', by taking her to Switzerland. At the end of their journey they visited Basel, and there in spite of her youth and her mother's scepticism Annemarie succeeded in attending the lecture cycle, *The Gospel of St Mark*. She had no inkling of the eurythmy lessons that were going on at the same time. Around Christmas 1912 Annemarie was at home in Berlin when a friend visiting her mother told of a new art of movement.

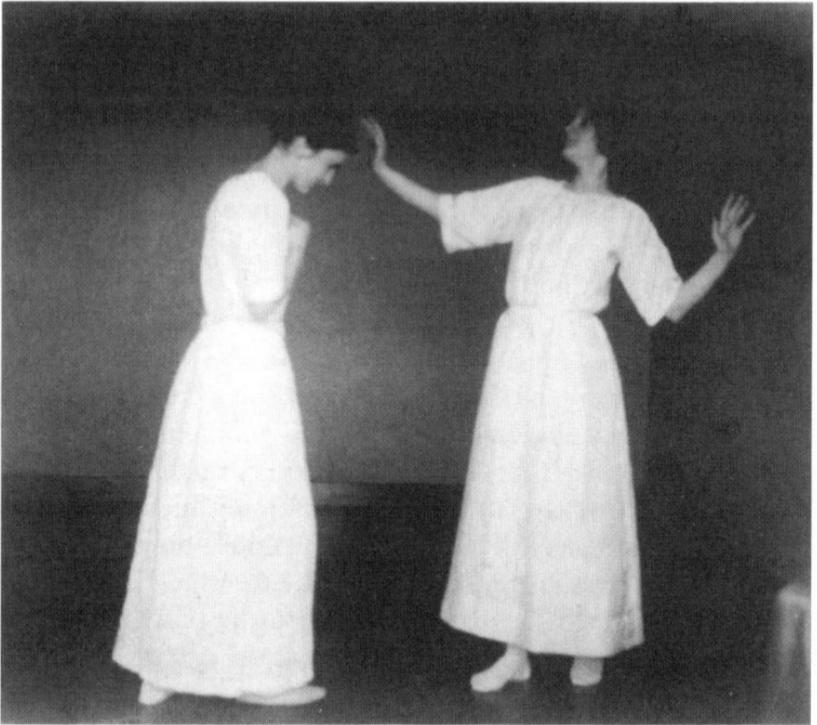

Annemarie Donath and Lory Smits (right).

Annemarie was enthusiastic, would not give in, and insisted on going to Haus Meer for three months to learn it. She arrived there in March.

In mid-April a third young lady arrived, Erna Wolfram. Erna had studied voice at the opera school in Leipzig. She had then become very ill, but wanted to continue the training after her recovery. Rudolf Steiner invited her for a chat, saying he 'had a much nicer career for her'. When she came he told her she must devote herself to the new dance form which he had begun a few months earlier. 18 year-old Erna responded:

'... Dr [Steiner], I'd do anything for you, but I won't dance.' He looked at her quietly for a long moment and said, 'But you will like [...] this form of dance—because it comes from the ancient Greek mysteries!' This word found resonance in her being, for she had been attending Rudolf Steiner's lectures since she was 16. Rudolf Steiner continued, 'So you'll go to Haus Meer near Düsseldorf, won't you—Lory Smits lives there—and let her show you everything I have shown her, and then in two weeks I myself will come, and then we shall work together on eurythmy...'

The motives of these two individuals for going to Haus Meer were totally opposite. The one had come with the whole force of her own will; the other had to be practically forced to go. Yet both were introduced to eurythmy in such a way that they remained true to it for the rest of their lives.

Lory felt encouraged by Annemarie Donath's coming and by the fact that Rudolf Steiner had sent Erna Wolfram to learn from her, without even having seen what she had done.

During the 17 months from the death of Henri Smits until the first eurythmy presentation on 26 April 1913 there had been dramatic developments within the Theosophical Society. These had an important impact on Rudolf Steiner's work. Hampering as well as favourable influences made themselves felt. Already in 1907 there had been differences of opinion between Rudolf Steiner and the leadership of the international Theosophical Society. In 1912 it came to a crisis. Rudolf Steiner had to devote much time to clearing up these problems. Yet he did not want to postpone his spiritual-scientific and artistic work because of it. He went ahead with the performances of the mystery dramas and with developing eurythmy.

On 11 December 1912, the executive committee of the German Section of the Theosophical Society disassociated itself from statements that had been made by the leadership of the world Society, which had moved its centre from London to

Erna Wolfram, 1915.

India. On 28 December 1912 in Cologne, the Anthroposophical Society was founded. Its first general meeting was held in Berlin on 3 February 1913. This made it possible for Rudolf Steiner to continue his lecturing and artistic projects without interruption when Annie Besant withdrew the deed of the German Section in March.

An overview of this period shows that eurythmy arose as part of a broad stream of artistic creativity within the anthroposophical movement. One is surprised by the proximity of certain events; a particular constellation of destiny becomes evident. The Stuttgart Branch of the Theosophical Society inaugurated its building on 15 October 1911. It was the first house built to serve anthroposophical spiritual science, and the first in which an attempt was made to form the interior design according to Rudolf Steiner's suggestions, in order to bring it into harmony with spiritual life that was to be cultivated there. On 26–29 November 1911, Rudolf Steiner held four lectures to celebrate the opening of the domed room. Its 14 pillars with their sandstone capitals were a preliminary stage of what would appear later in the 14 wooden capitals of the Goetheanum in Dornach. At this time Rudolf Steiner told Imme von Eckardtstein, the painter who had painted the domed room, that he intended to found a 'Society for Theosophical Art and Way of Life'. Henri Smits died on 28 November 1911. His death led to the conversation between Rudolf Steiner and Clara Smits on 15 December, in which Rudolf Steiner agreed to train Lory in a new art of movement. The same day the founding members convened for the planned 'Society for Theosophical Art'. (This society did not materialise as planned, however.) A further expression of this artistic impulse was the *Soul Calendar 1912/1913*, with 52 weekly verses by Rudolf Steiner, and drawings by Imme von Eckardtstein. It appeared at Easter 1912.

Some of the members involved with the mystery dramas in Munich came to feel that a theatre should be built that would be more in keeping with the content of the plays. Rudolf

Steiner sketched a model for it in 1911. An application was submitted to the Munich authorities for approval, whereupon the project ground to a halt. After the lecture cycle and eurythmy lessons in September 1912, Rudolf Steiner and Marie von Sivers were invited to spend a few quiet days in Dornach at the country house of the family Grosheintz. The delay in acquiring building permission in Munich was mentioned, and Emil Grosheintz offered the meadows near his house as a site for the building. Rudolf Steiner and Marie von Sivers explored the whole area. In May 1913, when there was still no permission to build in Munich, they decided to build in Dornach. The foundation stone was laid in September 1913. We see here a remarkable coincidence in time and place between the preparations for the Goetheanum building and the emergence of eurythmy.

The development of eurythmy stands in close connection with the development of the architecture of the Goetheanum. After this wonderful, double-domed building carved in wood had burned down on New Year's Eve 1922, Rudolf Steiner wrote:

And when this art of eurythmy was performed on the stage of the Goetheanum, one was meant to have the feeling that there was a very natural relationship between the moving eurythmists and the stationary forms of the internal architecture and sculpture. The latter was meant to be pleased, as it were, to receive the former. The building and eurythmic movement were meant to grow into one.

And I know, too, that I shaped the forms of the building out of the same soul state from which the pictures for eurythmy come. Thus the harmony of the two was not striven for out of an intellectual intention, but arose out of a similar artistic impulse. Probably eurythmy could not have been found without the work on the building. Prior to the idea of the building, it was only present in its first beginnings.[33]

One cannot escape the impression that the destiny of Henri Smits (called to the spiritual world just at the time when Rudolf Steiner was so actively pursuing the new artistic impulse) reveals him to be an individual who was intimately bound up with the spiritual efforts going on in his house.

The Smits were very much aware of their departed relatives. It had been the death of 3 year-old Hans which brought Clara Smits to the Theosophical Society 14 years earlier, and it had been the unexpected death of her husband which led to the inauguration of eurythmy. And now Rudolf Steiner was to visit them in April 1913, while on a lecture tour with the theme of the relationship between the living and the dead.

Clara and Lory went to Elberfeld on 25 April to hear him speak. His lecture to inaugurate the room of the Branch in Elberfeld had the title 'Communication with the Dead'.[34] Afterwards Lory walked part of the way to his hotel with him, still filled with the impressions of what she had heard. Suddenly he asked her whether she wouldn't soon like to try a French poem in eurythmy. Hadn't her father loved France and the French language, and hadn't he probably preferred it to German! (She chose the poem *Le Matin* by Lamartine,[35] which she may well have found in her father's library. She performed it in 1914 in Berlin.)

Lory Smits' First Eurythmy Presentation

Rudolf Steiner arrived just before lunch on 26 April 1913, exactly seven months after the Smits had returned from Basel. With him came Helene Röchling and Mieta Waller. Adolf Arenson was already staying with the Smits.

The meal, as usual when Rudolf Steiner was there, was lively.

Then the performers disappeared to change. Lory wore a white dress; Clara Smits had chosen light green dresses for Annemarie, Erna and the four children. The salon had been

decorated with fresh birch branches. Here the guests took their places. For Lory it was an important and solemn moment. Had she been able to make Rudolf Steiner's indications her own and to bring them into visibility in such a way that they remained pure?

The programme opened with *alliteration*. Then the *exercises for control* followed. Lory had thought up a system for practising Rudolf Steiner's suggestion of stopping suddenly after moving swiftly: one big slow step, then stand; then within the same time-span, two steps, then stand; then within the same time-span three, four, five, six or seven steps and each time stand still again afterwards. In this way a smooth transition to standing could be achieved out of every tempo.

Next the audience had the opportunity of hearing and seeing the *basic metres:* iamb, trochee, anapest and dactyl, with steps and arm movements. When they presented Goethe's *Chorus of Blacksmiths* as an example of dactyl, Rudolf Steiner took the book from Clara Smits' hand and recited it himself.

> He gradually increased the tempo until we could no longer move fast enough. I think I have never heard anyone speak so quickly and yet with such clarity, rhythm and emphasis. At first we did the rhythm with arms and legs. Then, when it got faster and faster, it was no longer possible to do beautiful exact dactyls. We *were* dactyl now—nothing else existed anymore, we were swept up by it, as if wholly embodying it. It was a powerful experience! He then explained that we should *slowly* and gradually increase tempo and after the culmination *rapidly* become slower again.

For the *rod exercise* they used rods wrapped with gleaming copper. Lory had followed Rudolf Steiner's directions precisely—and also invented many imaginative variations in addition. For each rod position one firm step, or two stamping steps, or three light triplet steps; or two people face each other,

moving in mirror image towards each other and away, etc. Things became very merry after this as Rudolf Steiner took the rod from Lory and demonstrated the basic movements for five further rod exercises. (Lory developed these lovingly in the weeks to come. They are still used today for their healthy influence on posture and harmonious movement.) First Rudolf Steiner held the rod with his arms straight down and parallel, then he guided it along his body up to the shoulders—with his elbows outward—and said, 'This is a … healthy movement.' Then he held the rod in the same way behind him, with his palms facing forwards, and let it shoot up to his shoulder blades—his elbows backwards and the rod on his wrists, and said, '… and this is also a healthy movement!' Lory made this into the *Twelve Part* or *Opposites* exercise. Next Rudolf Steiner guided the rod from in front of him up over his head and behind, let it fall, and caught it with both hands. '… one does have to be skilful, so that the rod doesn't drop!' he exclaimed. They all tried it right away, but they weren't all so skilful, and the rods crashed down loudly onto the floor. This suggestion Lory made into the *waterfall exercise* (a name, though, which neither she nor Rudolf Steiner used). After further *dexterity exercises* he showed them the exercise which was later called the *spiral*.

After this light-hearted interlude the programme continued smoothly with the *energy* and the *peace dance, I and you, and we*. Lory stood in the middle, directing and speaking. When she joined the others at the end and joyfully ran to the centre in 'we', Rudolf Steiner turned to the guests with the often repeated words, 'Lory's steps are just right! She walks like a tightrope walker or a savage in the jungle.' And to Lory he said,

It isn't sufficient, that your steps are correct, you have to know *how* you do it. You have to [. . .] be able to explain it to your students. If you [. . .] can't do it, then we will have to photograph each phase of your step, so that it can be shown to your students later.

The next part of the presentation was devoted to making *personal pronouns* visible. Lory had examples for *I, you and we.* There were many variations of lemniscates carried out together in a circle. And then it was discovered that Lory had forgotten the forms for *he.*

This turned out to be a stroke of luck! Rudolf Steiner only said, 'I see, what you are lacking are texts. But I will provide them for you.' After a reflective silence, which the participants must have experienced as a truly creative pause, he asked the three oldest ones to form a small circle at the centre of the room. Then he spoke in a strong, ringing voice the first verse ever created for eurythmy:

> The Cloud Illuminer:
> May he illumine,
> May he sun-permeate,
> May he enkindle,
> May he warm through
> also me.[36]

He directed their steps meanwhile: during the first line, reverently take two steps backwards, forming a larger circle. During the four supplications, move around the circle with anapestic steps. During the last line again approach the circle's centre, the divine. They repeated it several times. Everyone was deeply impressed. This was an experience of what lofty tasks eurythmy would be able to take up in the future.

After this it was hard to continue with the prepared programme. But there was still so much to show! There was *expansion and contraction*, and the various *spirals.* Lory reports:

> Erna Wolfram, who of course could not be in everything yet, demonstrated the *big inwinding spiral* in spite of her short time of study. This exercise is good for 'strengthening the ego' and for pale people—and Erna was the palest one among us. She chose the consonant sequence D F G K H.

After all the disturbing influences of the outside world had been fended off with these, she arrived by way of L movements at the final position EU (oi),[37] with 'hands near the heart'.

Particular care had been taken with *Evoe*. A large, regularly-formed pyrite crystal, which Henri Smits had brought home from Italy a few weeks before his death, was placed at the centre of the circle. They touched it with the V gesture. In Bottmingen Rudolf Steiner had described how *Evoe* was to be done:

> One should form a circle around something to be revered—around a number of beautifully shaped minerals, a vase with flowers, a child—but never around an every-day, indifferent object such as a chair [...] approach the thing to be revered with a reverent E (ay) gesture, and then with a very small second step kneel deeply down, quietly and reverently with arms stretched far out in front to touch this holy thing: V; then form an O while raising oneself up again, and step back into the circle with the last E (ay), finishing the greeting.

(Rudolf Steiner had gladly accepted the most beautiful crystal of the pyrite collection, in memory of Henri Smits. When Lory heard—it was probably decades later—that Rudolf Steiner had put two pyrite crystals shaped like pentagonal dodecahedrons into the foundation stone of the Goetheanum, she wondered if one of them might have come from her father's collection.) A further *Evoe* for two, and an L exercise with music, shown by Lory and Annemarie Donath, led the first part of the presentation to its solemn conclusion: the *Hallelujah*.

After a break Lory showed the two poems *Ocean Stillness* and *Happy Journey*, which still rather dissatisfied her. The forms were very simple at first, and 'I [...] did it after a fashion, for my struggle with the many consonants was still unresolved.' Next the three eldest ones showed Clemens

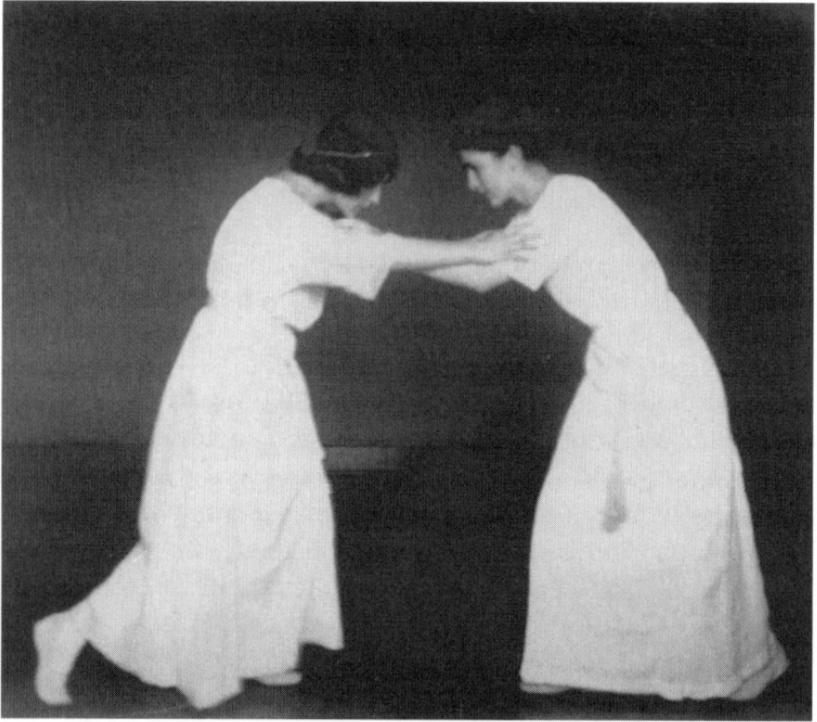

Elisabeth Dollfus and Annemarie Donath (right), 'Evoe,' 1913.

Brentano's *Cradle Song*,[38] and to conclude the programme came the *circle dances* that Rudolf Steiner had drawn at the preparatory lesson in Kassel. They did them with many variations—by including the *soul gestures* for 'solemn', 'loveable', 'tender', etc. Lory had found music which was suitable— Robert Schuman's 'Semplice' from *Papillons*.

Something of their very high spirits during this first eurythmy 'performance' emerges from Lory's later report: 'We were full of joy and elation, and once we had shown the tasks one by one in the order that he had given them, he was glad, satisfied and infinitely benevolent and positive.'

Now everything dispersed into contented, lively, cheerful conversation. The three guests had not only made the acquaintance of the new art, they had learned to love it. Adolf Arenson (who had composed the music for the mystery dramas) wrote down that very evening some music for the rod exercise 'spiral'. Mieta Waller (who had played the role of Johannes in the mystery dramas) became a eurythmist herself a few years later—unforgettable to all who saw her unperturbed, brilliant characterization of 'Korf' in Christian Morgenstern's *Gallows' Songs*. Helene Röschling became a good fairy to eurythmists, 'for she sends to us eurythmists / the most lovely clothing gifts',[39] they said.

Since Rudolf Steiner had a lecture to hold in Düsseldorf that evening, he soon said goodbye.

And then something happened which I do not mention because of me, but to show how great, kind, supportive and positive he was. He took my hand in both of his and [...] thanked me. When I, taken aback, stammered with dismay, 'But ... *we* must thank *you!*' he took my hand again and said, 'No, I thank you.' At the door as well, before he got into the car, a handshake and, 'I thank you'.

The next day Rudolf Steiner gave a lecture to members of the Theosophical Society, again with the theme 'Communicating with the Dead'. He told those present that a connection remains between the dead and the people who had been close to them in life. He said:

There beyond death our closest relationships continue. And in this regard much can be done, just especially by those who have remained behind here, those whom we term the living. For one who remains behind can give tidings to the dead—because of the connection between them—tidings of his own knowledge of the supersensible world. This is mainly possible through reading to the dead. We can do the greatest service for the dead if we sit down, with the picture

of the dead person before our soul, and quietly read a spiritual-scientific book to him, teaching him. One can also carry to him one's own thoughts that one has taken into oneself; always imagining the picture of the dead person vividly.[40]

At the end of the lecture there was an opportunity to ask questions. To the question whether one can also read to children who have died at birth or very young, Rudolf Steiner replied,

One is a child only here on the earth. Sometimes it is revealed to clairvoyance that an individuality who died as a child is less a child in the spiritual world than many who die when they are 80 years old. Thus one cannot measure by the same standards.[41]

Then he described how he had been able to gain insight into an especially elusive supersensible fact because of someone who had died early, adding, 'So I would say that one can also read to children who die young.'[42]

Did Clara Smits ask that question? We do not know. The answer must have touched her innermost being.

After this last lecture Lory received a further task. She should try to do Goethe's *Charon* in eurythmy, a poem inspired by the epics of ancient Greece.

> *Charon*
> The rocky heights—why sudden black?
> Whence come these cloudy masses?
> Is it the storm that battles there,
> Rain flailing at the mountain?
> 'Tis not a storm that battles there,
> Nor rain flailing the mountains,
> No, it is Charon charging by,
> With hosts of the departed;
> The younger ones he drives before,
> The old he drags behind him;

The youngest, though, the infants hang
From saddle bow in garlands.
The aged cry to him to halt
The youths, they kneel before him
'O Charon, hold on by the ledge
Pause by the cooling fountain!
The old ones would refresh themselves
The young toss stones about them
The tender lads would scatter wide
To cull them wreaths of flowers.'
'I cannot pause beside the hedge
Nor linger by the fountain
The women come for water there
They'll recognise their lost ones
The men would know their children too,
None could endure the parting.'[43]

The first and last six lines should be done with vowels; the middle part with consonants. Lory should find the form herself and also something to use as an object for V, B and S. If we knew nothing about the particular feelings that the lecture probably called forth in the audience, it would remain a mystery why Rudolf Steiner gave such a dark, serious poem to this happy young girl, after her successful debut. However, he didn't mean her to bring out the dark side of *Charon*, for he asked her to wear a golden-yellow dress at the performance in August.

With fresh enthusiasm they continued to practise until mid-June 1913. Every morning, Lory Smits, Annemarie Donath and Erna Wolfram repeated the basic elements of eurythmy. They practised sounds, sound-connections and the movements for metre and rhythm. They looked for poems for personal pronouns, soul gestures and 'thinking', 'willing' and 'feeling' forms. Lory developed the new suggestions into rod exercises. Together (without a camera) they tried to make Lory's 'correct steps' conscious. After much seeking, experi-

menting and discarding, they developed three phases. They called lifting the foot: 'rebelling against the earth-bound state', guiding the foot over the floor: 'aiming for the goal', and placing the foot: 'vigorously touching the earth again.' It filled them with pride and joy in 1924 when Rudolf Steiner described the threefold aspect of the step as 'will-impulse—thought—deed', in full agreement with their own results.[44]

In the afternoons when the children could join them, Lory acquired practical experience in creating and directing group-forms.

Just after Lory's death in 1971, Annemarie Dubach-Donath wrote in memory of her:

> In spite of her youth she was a wonderful teacher, for she possessed all the virtues that a teacher must have: thoroughness, clarity of thought, untiring patience (which she also demanded of her students); and to balance it, she was very imaginative and vivacious. I had the good fortune to be her first student, in 1913. [. . .] when I remember back to the bright, small, light-green room where we practised (the door opened directly onto the garden) then I see that young teacher [. . .] devotedly directing the rest of us—also her younger sisters—with zest and élan. There was a genuinely Greek element in all that she did, a Dionysian fire, and she infected our [. . .] little group with it, so that those hours of practice (which went on morning and afternoon almost without a break) were as if immersed in Hellenic light, in shining youthfulness and promise.[45]

— 16. —

Dionysischer Friedenstanz.

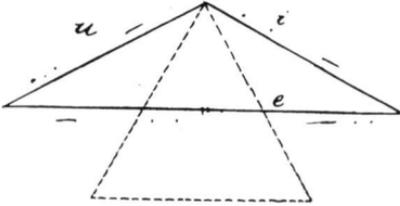

Wird in Annaposten gemacht, und dem äus-
seren Fuss begonnen, Gefühl des Vorbei Kommens,
Rücksicht nehmens bei den beiden e

Der Tanz kann wie der folgende ein Kreis ge-
macht werden. Dann ruft man in der Mitte
Stehender.

— 17. —

Energie Tanz
Fordert Energie zu gemeinsamer Arbeit

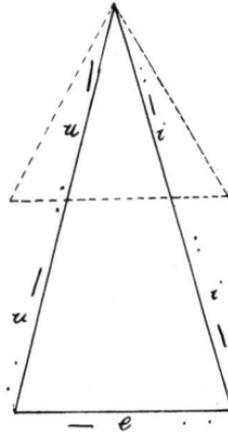

Ebenfalls in Annaposten, doch wird mit
dem inneren Fuss angefangen, Gefühl des Er-
reichen wollens.

From Lory's preparations for introductory classes, October 1913 in Stuttgart.

5.
August 1913. Eurythmy première during the summer drama festival of the Theosophical Society in Munich

Lory's new capacities came to splendid fruition at the drama festival in Munich, in July 1913. That year the fourth mystery drama, *The Soul's Awakening* received its première and *The Guardian of the Threshold* was repeated. About twelve hundred members had registered for the festival, making it necessary to perform each drama twice, and Rudolf Steiner held his lecture cycle *Secrets of the Threshold* twice as well.

When Lory arrived at the familiar Schwabing gymnasium for the rehearsal, Rudolf Steiner began to explain to those assembled that in the second scene of the newest drama there would be groups of elemental beings—sylphs and gnomes. Then he told the amazed participants that a new stage art had been in quiet preparation for roughly a year, and that in order to portray the sylphs and gnomes, this 'eurythmy' would 'be made use of for the first time'.

He assigned them to two groups. Then he said to 20 year-old Lory, 'Well, Miss Smits, you know the principles, so you will be able to create the forms for these groups. If you work in the lunch-break with the ladies who I have assigned to the sylphs, then there will already be something for me to look at this afternoon.'

Lory wrote later:

So we met [...] back in the gymnasium soon after lunch. After I [...] had shown them each vowel and diphthong [...] we began without a theoretical explanation to practise, line for line, very slowly, repeating often. I stood in front of them doing the gestures, speaking slowly and stressing the main vowels.

It went surprisingly well right from the start. Rudolf Steiner had chosen just these individuals for good reason. The stage directions read: '... sylph-like, slim, practically headless figures; their feet and hands are a cross between fins and wings...'. And so I had a row of lovely slim figures in front of me, among them Tatjana Kisseleff, Alice Fels, Margarita Woloschin, Edith Maryon—all of whom did not find it difficult to make large airy floating movements, and who would evidently be able to glide as if swimming. But on this afternoon we were not yet so far. We were fully occupied with the arm movements, for it was absolutely new terrain for all of them, except Erna Wolfram. But they found their way into it with ever more joy and enthusiasm.

Margarita Woloschin described the same rehearsal from the point of view of a 'sylph':

> ... Lory Smits, a slim girl with chestnut brown hair and sparkling blue eyes framed by dark lashes. She was like a Greek *kore*—especially her arms reminded me of Greek sculpture. [...] When one saw Lory Smits demonstrating individual sounds, one held one's breath. There was something in her movements like a bud—something physically held back, etherically radiating out into space [...] She was like a young priestess; there was something Apollonian and radiant about her.[46]

Lory herself was assigned to the gnome-chorus. The stage directions read, 'They have steel-grey forms, small compared to people; they are almost entirely head, but the head is bent forward. They have long supple limbs, suitable for making gestures, awkward for walking.' The special gestures needed for the gnomes were so different from anything Lory had learned so far that Rudolf Steiner demonstrated them himself. He

> took [...] a parasol in each hand and with thus lengthened arms he made rather hard, [...] characteristic, very graphic

movements (because his head was stretched forwards) for all the vowels. At the same time with continually bent knees he walked little triangular forms, sharply emphasizing [...] the corners by jerking to a halt—as if he were stumbling into each new direction, startling his audience—indeed, frightening us.

It is true that we had already often experienced his unsurpassable capacity for transformation, for example when he demonstrated Lucifer or Ahriman. But this was something else again. A being, totally foreign and grotesque, appeared in front of us with frightening intensity, coolly mocking our human wisdom as stupidity.

The painter Imme von Eckardtstein eagerly sketched Rudolf Steiner's facial expressions; and later she let these sketches inspire her when she painted faces onto the broad oval stoles that these beings 'which are almost entirely head' would wear, while their own heads were covered in gauze. After the dress-rehearsal Rudolf Steiner came over to Lory beaming, and said ' "You really did find [...] all of the gnomes' characteristic movements—except for one which they often make, however, it would have been too impudent!" And he laughingly thumbed his nose at me!' The ever humble Lory assured him that the Danish Baroness Walleen also deserved this praise, for her original ideas had greatly contributed to the successful outcome.

About two weeks before the performance Rudolf Steiner asked Lory (with Erna Wolfram, Margarita Woloschin and the French painter Madame Péralté) to portray four priests in the new drama's eighth scene, which was set in an Egyptian temple. At first they were to stand motionless in the background; later they would move. Lory went immediately to the museum to look at Egyptian sculpture. Reliefs of figures in movement gave her the idea of having the four priests do their eurythmy gestures with sideways arm-movements only. Madame Péralté (an extraordinarily energetic and tempera-

mental lady in spite of her nearly 60 years) did not agree with
these 'Egyptian fantasies'. To push through her point of view
she not only brought thick volumes to the rehearsal, but also
an Egyptologist. Finally Rudolf Steiner said to Lory, 'Then
leave those side-movements out'. Afterwards, when Lory was
dejectedly creeping down the stairs, Rudolf Steiner kindly laid
a comforting hand on her shoulder and said, '...I did not
mean it so pedantically, that you should leave out the side-
gestures—only at the end. That should definitely be done in
front of you, in the line 'I felt your urgent summons to awake.'
He explained that this had been a moment in Egyptian culture
when an 'indication of the approaching *Greek* culture
appeared for the first time'. Lory passed this on to the others.
It was an inspiration for their further collaboration, and the
change from side to frontal gestures must have been a good
contribution to making the dramatic message clear.

'Already before [...] the rehearsals began in Munich [...]
introductory lessons in an art of movement inaugurated by
Rudolf Steiner had been [...] announced.' So the members
were surprised, expectant, open, interested, and probably a
little curious. Because of the rehearsal plan, lessons were in the
early mornings and afternoons. They took place in the 'art
room', so appropriate a place for eurythmy to flow into the
culture of the time.

Marie Steiner wrote:

These art rooms deserve to be remembered. For they can
undoubtedly be traced back to the inspiring influence of
Rudolf Steiner's social activities and his respect for human
beings—even though the actual initiative sprang from the
warm hearts of two artists who led the anthroposophical
work in Munich, Miss Stinde and Countess Kalckreuth [...]
These art rooms were meant for the broad public, as hos-
pitable places which should offer not only warmth and
comfort, but also beauty, aesthetics, and spiritual inspira-
tion. [...] Each month there was an exhibition. There were

evening programmes with music and recitation, an intro-
ductory course in spiritual science—and also other areas of
study. On a modest scale it provided nourishment for the
souls of people from the working population in search of
spirit...

The members of the Anthroposophical Society who were
involved with the mystery dramas were the first to find their
way to eurythmy. Tatjana Kisseleff wrote: 'In Munich every
member who could manage it registered for the introductory
course in eurythmy. And in that small narrow room [...] one
sometimes had to wait a long time for one's turn...'.[47]
 Elisabeth Dollfus, for whom this course was a major turn-
ing point in her life, wrote:

Eurythmy found willing souls in whom had lived for years
warm, enthusiastic devotion to the spirit treasures passed on
by Rudolf Steiner. The seed of a new art flowing from the
same source could therefore [...] develop amazingly quickly
in them. [...] It was like when one [...] opens the door after a
night-time snowfall and the path to the garden gate lies
before one; an untouched, pure, almost unearthly surface,
which gives rise to a strange feeling of joy when one walks
on it—this is how we felt about the new art. A new creation
had come down [...] it was new ground; no human foot had
yet trod upon it.[48]

Lory herself remembered:

By eagerly attending the courses many people met eurythmy
with glad enthusiasm and spontaneous understanding.
Many [...] came only to watch, saying that Rudolf Steiner
had warmly urged them not to miss going over to the art
room to have a look at 'our new art of movement'. So Erna
Wolfram (who was helping me) and I had to find our par-
ticipants one after another from among the 'multitude' of
onlookers.

A soft expectant glow lay over those first courses, like the mood of early morning, when we can only dimly sense the full glory and beauty of the sun. This glow came from all the heartfelt, joyful willingness which everyone 'brought towards the new art and which [. . .] made it possible to attempt a first performance with some of the participants, at Rudolf Steiner's request, as an initial orientation for the others'.

Rudolf Steiner left it to Lory alone to direct and organize this performance. He only said, 'Do something similar to what you did at Haus Meer, [. . .] but try for a more well-rounded, artistic form.' This must have been successful, for decades later members who had been present still spoke enthusiastically about it.

At this first eurythmy presentation Rudolf Steiner gave an introductory talk.[49] He expressed the need for the audience to look at this new art in the right way by describing a humorous conversation between Capesius, the intelligent history professor, and Felicia Balde, the hearty, uncomplicated teller of fairy-tales. (Both characters were still fresh in the minds of the audience from the dramas which had just come to an end.) Felicia thinks that the professor fails to understand her fairy-tale figures because he cannot listen properly and she cries out, 'Yes, you see, you must understand the art of letting your heart rise up into your head for awhile. Then you will get a peculiar sense for all of the movements which the elves, fairy-tale princes and fairies are making.' It was the same guiding principle that Rudolf Steiner had given to Lory in Bottmingen: 'You must learn to let your heart rise up into your head—not the opposite, letting your head go down into your heart.'

Then Rudolf Steiner explained that eurythmy has three impulses or aspects: the aesthetic, the pedagogical, and the hygienic.

Elisabeth Dollfus reported, 'There were no external aids to add to the effect [. . .] such as lighting or many-coloured veils and dresses. It all happened in prosaic afternoon light on an

undecorated orchestra podium framed by a few laurel trees. We wore plain white, rather long dresses, with silk sashes around the waist.'[50]

The programme consisted of three-part walking with head positions and soul gestures—Evoe—rhythms—rod exercises—energy and peace dance—*The Cloud Illuminer*—vowels and consonants—Goethe's *Ocean Stillness* and *Happy Journey*—Clemens Brentano's *Cradle Song*—the 150th Psalm with *Hallelujah*—and Goethe's *Charon*.

Margarita Woloschin was deeply impressed:

> I still remember how the first time I saw the poem [*The Cloud Illuminer*] in eurythmy I was moved to tears. [...] Three figures moved in a circle, facing the centre. They created living architecture, a visible prayer, as they raised their hands, spread them out or crossed them, made a step away from the centre or towards it. I had the same experience with *Hallelujah* and *Evoe*. [...] When Lory Smits performed Goethe's *Charon*, dressed in yellow, with the Tao in her hand, her sacramental movements gave it greatness and depth...[51]

Lory had prepared *Charon* all on her own. Rudolf Steiner had merely recommended that for this highly dramatic poem she exchange the plain white dress for a golden-orange, austerely cut, silk dress with a wide belt, and that she paint the wooden hammer gold. Imme von Eckardtstein found a masterful solution to this problem (the dress had to allow for free movement). Lory had chosen a hammer for doing the sounds V, B and S because she had read that Charon used a hammer when he opened the portal to the Underworld on his way down with deceased souls. Elisabeth Dollfus reported: 'It was surely no easy task to pick up and put down that hammer in the middle of moving around the stage and making gestures. She did it with great skill, and this first performance of a dramatic poem was an unforgettable experience for the audience.'[52]

Lory Smits, 1913 at Haus Meer.

Lory Smits, 1913 at Haus Meer.

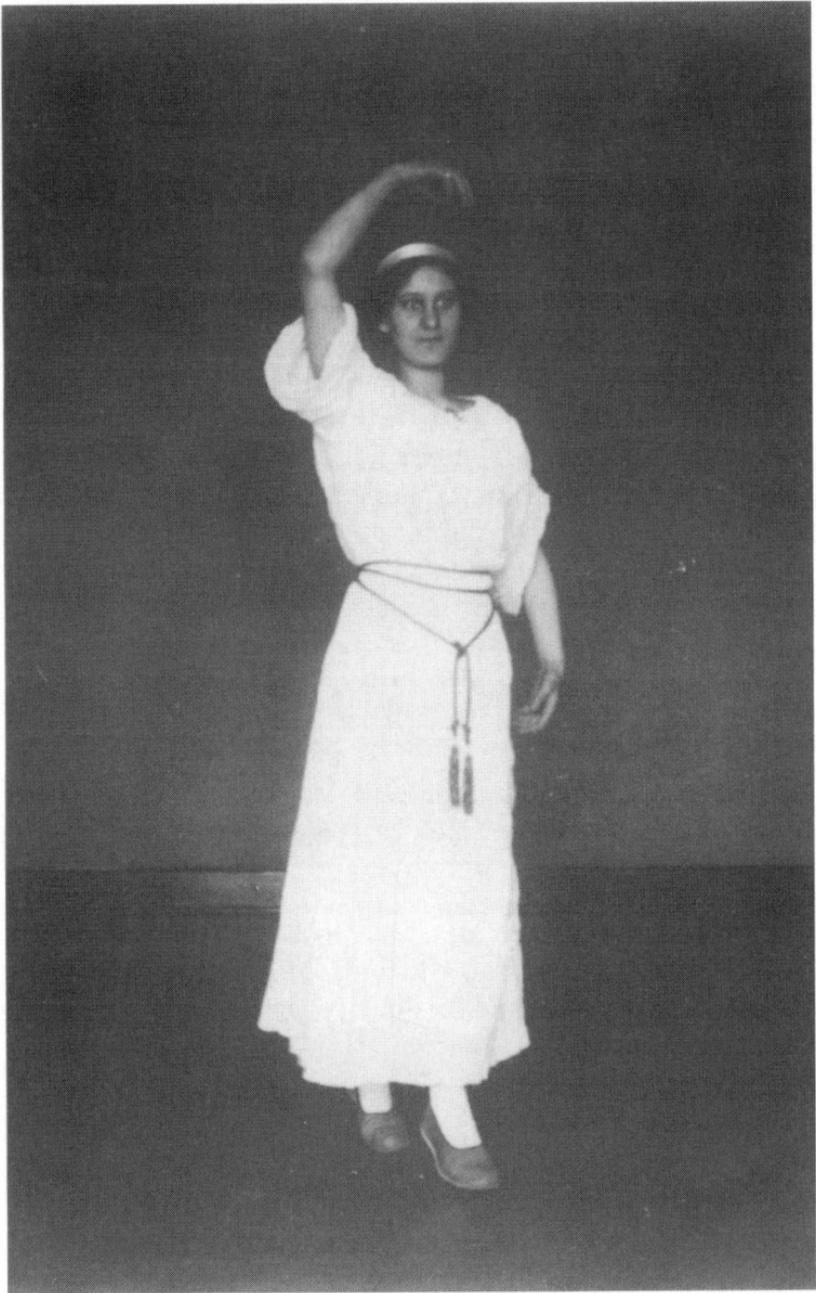

Lory Smits, 1913 at Haus Meer.

Assja Turgenieff reported, 'The eurythmy performance organised by Lory Smits was a great event [...] Some young men, all in white, demonstrated rod exercises. Very impressive was a poem by Goethe, *Charon*, which Lory Smits performed. She [...] swung a golden hammer, striking the floor with it at certain moments in the poem.'[53]

As appropriate for a significant new performing art, eurythmy's first public appearance was brilliantly staged. Twelve hundred members of the Anthroposophical Society first saw it's elevated portrayal of a sphere to which it so fittingly belonged: that of supersensible beings (luciferic and ahrimanic beings and gnomes in the mystery dramas). The audience of this performance became acquainted with the basic elements and also the variety of application (hymnic, lyric, dramatic). Those interested could attend workshops, and those who participated in the performance had already taken an intensive introductory class.

Lory was responsible for nearly all of it; strengthened by Rudolf Steiner's trust, she tirelessly and enthusiastically represented eurythmy.

Once the lecture cycle came to an end, the participants returned to their different homes, spreading the word of this new art of movement, eurythmy.

On the last day, when Lory went to Rudolf Steiner to say goodbye, she received two new indications: an exercise with the theme *I am here*,[54] and a wonderful gesture requiring great body control:

Make an U (oo) gesture with your arms, very high above your head, and now sink down slowly very far into the knees—not *onto* the knees—stay on your feet and in sinking down bring your arms down in front of your chest, simultaneously lowering your head. Remain for a little in this position and then raise yourself just as slowly up again, taking arms and head with you, to the starting position. If

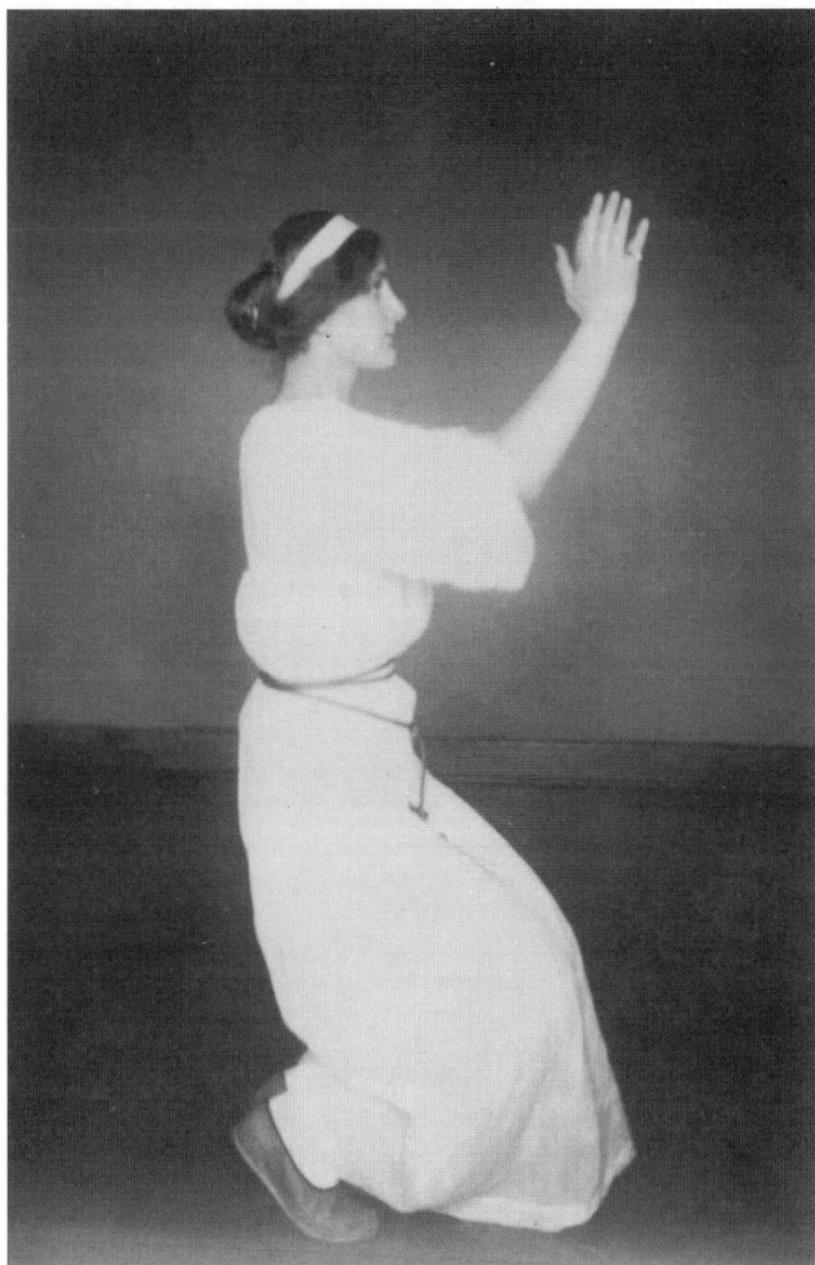

Lory Smits in the soul gesture 'I look up,' 1913.

you really let this movement arise out of the feeling *I look up*,[55] it will be an especially beautiful and solemn movement.

6.

1913–1914. Lory Smits gives courses within the Anthroposophical Society and trains eurythmists

From Munich Lory travelled directly to Stuttgart. There, throughout September, she gave courses in eurythmy for adults and children. Rudolf Steiner was glad that the 'very active and important Stuttgart Branch' had already expressed a wish for eurythmy courses. Lory taught in the Branch room on Landhaus Street where Rudolf Steiner had been staying and lecturing at the time that Henri Smits died.

From then on during the next years Lory very diligently went wherever she was asked and taught with enthusiasm in many towns.

Her preparatory notes were meticulously exact. By drawing and describing the exercises, she made every step, every head position and every sound conscious. Her lessons themselves, by all accounts, however, were lively and high-spirited. She responded to questions lovingly, she was resourceful in helping with any awkwardness or difficulty, and she confidently responded to unexpected situations. It was important to her that every lesson have moments of serious inner concentration as well as moments of utter ease and amusement. During the next months Lory gave introductory courses in Düsseldorf and Cologne.

Elisabeth Dollfus had been so impressed by the eurythmy course in Munich that she wanted to take up eurythmy as a career. Rudolf Steiner asked Clara Smits whether such a training could be set up at Haus Meer. She was very glad and willing. Others heard about it, and thus in October 1913 a group of very different individuals, filled with the desire to learn the new art, came together: Tatjana Kisseleff, Margarita Woloschin, Natalie von Papoff, Elisabeth Dollfus, Peggy

Meltzer and Irene Hilverkus. Margarita Woloschin did not intend to give up painting, but she had been so deeply moved by eurythmy that she hoped for new impulses from it for her work. A life-long friendship arose between her and Lory. At weekends Edith Röhrle joined them from Rheydt. When a larger number of participants was needed for certain exercises, then Lory's sisters joined in.

Lory endeavoured to pass on Rudolf Steiner's indications in a pure and direct form. In training the others she was very strict with regard to the exactness of the exercises and basic elements, but left them free in their artistic interpretation. She wanted the laws underlying eurythmy to come to expression, even if modified by individual artistic creativity.

Once a week she gave courses in Cologne and Düsseldorf. The group's zest for work at Haus Meer increased even more when Lory was asked to prepare a 'proper' performance (rather than demonstrating basic elements), to be shown in Cologne before Christmas, as a solemn festive contribution in connection with Rudolf Steiner's lectures at that time. Erna Wolfram joined in for this, replacing Peggy Meltzer.

On 17 December 1913, Rudolf Steiner held the first of two lectures in which he presented powerful pictures from the life of Jesus of Nazareth.[56] On the following afternoon these pictures were still echoing on in the hearts of the audience and performers as the 'Christmas Story from the Gospel of Saint Luke' was performed, with the *Hallelujah*. Before it they did *Hyperion's Destiny Song* by Hölderlin, and afterwards the allegretto from Beethoven's Symphony No. VII.

There was no tone eurythmy at that time. The performers made the rhythms in the music visible with their steps. Moods were expressed with soul gestures such as 'solemn', 'happy', 'tender', etc. Especially dramatic accents were achieved by striking small melodious hand cymbals.[57]

Elisabeth Dollfus wrote: 'This fruit of our three months of eurythmy training grew ripe through intense mutual work,

Training course at Haus Meer, Düsseldorf 1913: From left to right:
Irene Hilverkus, Natalie von Papoff, Margarita Woloschin,
Annemarie Donath, Tatjana Kisseleff, Lory Smits, Elisabeth Dollfus,
Adele Smits, Thea Smits. Autumn 1913.

leading to a performance more full of atmosphere than any I can remember.'[58]

The next, expanded performance was to take place on 21 January 1914 in Berlin. Lory invited Annemarie Donath to join them, and they continued working with vitality and enthusiasm through Christmas to mid-January.

In Berlin, from 18–23 January the General Meeting of the Anthroposophical Society took place. Rudolf Steiner held four lectures entitled *Human and Cosmic Thought*. He described a way in which thinking can become living and mobile again by fully imagining and thinking one's way into the

variety and validity of the 12 world views anchored in the zodiac.

On the afternoon before the first lecture Erna Wolfram gave a solo performance which stimulated the audience to develop flexibility in their sense of language. She showed texts from five ancient languages which she must have prepared with the help of her mother, Elise Wolfram, who was very knowledgeable about them. It was the first Psalm in Hebrew, excerpts from the Odyssey in classical Greek, verses in Sanskrit, and prayers in Old High German and Latin.

Lory's group performed on the afternoon before the second lecture. Before the performance began, Rudolf Steiner gave an introductory talk. Without once mentioning the word eurythmy he presented the importance of the new art as a great prospect for the future of human culture, appealing movingly to the members to be willing to take it in.

He began:

> My dear friends! Perhaps you will discover a certain connection between what I said last night about intimate matters of human thinking, and what is intended by the following presentation. Last night I spoke of the fundamental need for healing the thinking and world-view of our time, the possibility of bringing human thinking, human thought, away from its present rigidity, out of its frozenness, into movement again.

At this point he quoted Fritz Mauthner, who, in his book *Critique of Language*[59] expressed deep despair about his contemporary cultural situation, feeling confronted by the death of thinking, the death of language. Rudolf Steiner continued,

> Such things came to mind more than a year ago when it became possible—because I found a suitable individual in Miss Smits—to make the attempt, out of the fount of the creative Word of the world, out of the source in which the

Annemarie Donath, Lory Smits and Elisabeth Dollfus
(from left to right).

Logos, the Word, is creative in the world, to look for that in
the human etheric body [...] which [...] calls up the gesture
which expresses that life, not death, is impressed in the
human body...

You will see that the most lofty heights to which the
human word can raise itself can pass over into movement...

Nothing would be better than if as many friends as pos-
sible—if many anthroposophists—would exert themselves

so that these forms of expression connected with innate movements of the human etheric body, which become movements of dance, may stream into human culture as a healing element...

May our anthroposophists recognize at the right time that they have something here which they really can carry out into life, which will have a healing effect. Through suitable exercises the child's organism will find its way already in earliest childhood to the natural movements of the etheric body, so that health and healing forces will be carried over into the rest of its life.

It is important that high and lofty thoughts radiate into the human etheric body from an early age, that the human being becomes one with them; then his whole being will be penetrated with healthy moral feeling and moral thinking.

The programme that followed began with *Hyperion's Destiny Song* by Hölderlin:

> Ye wander up yonder in light
> On velvet sward, o blessed Genii!
> Radiant air divine
> Touches you lightly
> Like the finger of lyre-player
> Holiest strings.
>
> Destiny-free, like the sleeping
> Babe, breathe lightly the heavenly ones.
> Chastely preserved,
> As in calyx enclosed,
> Blossoms ever
> Round them spirit,
> And the eyes of the blest
> Glance with silent
> Eternal Clarity.
>
> But to us is given,
> In no place to rest our head.

Soul gestures; Elisabeth Dollfus, Lory Smits and Annemarie Donath
(from left to right).

> There dwindle, there tumble
> The suffering humans
> Blindly from one dark
> Hour to the other,
> Like water from rockface
> To rockface descending,
> Year-long down into unsure depths.[60]

Lory had found an ingenious way of doing it. The first verse
they all did together in the style of *The Cloud Illuminer* and *In*

Praise of the Gods; in the second verse a soloist emerged—the separation of the individual from his origin—while the others stepped the rhythm in the background as chorus; in the third verse 'the feeling of all humanity' found expression in a single giant lemniscate from the back of the stage to the front, as an expression of drama and tragedy. The destiny of the human ego was thus made visible not only through the thought content, but also in eurythmy.

The motif of the second number in the programme, 'Penitents and Gretchen', from Goethe's *Faust II*, was the soul's ascension into higher regions. Annemarie Donath portrayed Gretchen. It was the first time that verses from this tremendous work of world literature were done in eurythmy. There followed two poems in Russian, *White Bellflower* by Soloviev and *The Prophet* by Pushkin. Lory showed the French poem by Lamartine that she had chosen in memory of her father. The *Ecossaises* by Beethoven led over to the culmination of the programme, the 'Christmas Story from the Gospel of Saint Luke.'

This presentation of eurythmy in Berlin and Rudolf Steiner's appeal to the members to include eurythmy in their activities broadened the basis for eurythmy's further development. It awakened also a consciousness of eurythmy as a career.

Thus those who had learned from Lory began to unfold their work in many places. Erna Wolfram gave regular courses in Leipzig and Hamburg, Elisabeth Dollfus in Munich, and Tatjana Kisseleff began in Berlin but moved to Dornach in March 1914 and there at once rented a room in the guesthouse Jura, setting up courses for adults and children.

Lory herself, before returning home to Haus Meer, gave several courses in Berlin and afterwards in Kassel. With Rudolf Steiner's glad approval she had already been asked by Harry Collison, representative of the Anthroposophical Society in England, whether she could come to London for performances and courses. In mid-April he visited Haus Meer

*Soul gestures; Elisabeth Dollfus, Annemarie Donath and Lory Smits
(from left to right).*

to prepare it with her. It was not always easy to translate Rudolf Steiner's specific indications into English. When Lory translated, Harry Collison felt that it was poor English; when he translated, she felt that it did not correspond to what was intended in eurythmy. It was easier for them to find English poems and verses.

In order to form a small performing group, Harry Collison invited Elisabeth Dollfus, Flossy von Sonclar and Ada Smits in addition to Lory. Clara Smits brought along her house-keeper to ease the strain on their hosts. (This housekeeper managed to communicate well in London with her 'Platt-deutsch' dialect!)[61]

After these careful preparations Lory felt she could risk giving courses in English. In London throughout all of May they worked diligently—also in the small group, for there was a performance each week with poems in English and German and *Ecossaises* by Beethoven. Everything had been excellently arranged by Harry Collison and he looked after them lovingly.

In June a new training course was to begin at Haus Meer. But the political situation was so uncertain that the English students did not want to risk the journey; the beginning was delayed.

Lory had already decided a year before that she would prepare a chorus by Sophocles for the summer festival of 1914. She had taken lessons in classical Greek and familiarized herself with the special metric forms. Now she learned that there would be no festival in Munich that year. Everything was up in the air and undecided.

The Smits' support for Lory's career as a eurythmist can be seen from the advertisement in the June 1914 edition of the 'News for the members of the Anthroposophical Society'[62] put out by Mathilde Scholl. In the section 'Rooms and places for recuperation, with vegetarian meals' it reads: 'Haus Meer, Post Osterath, near Düsseldorf, rooms in the country and eurythmy lessons in the summer months from July onwards. Mrs C. Smits.' This initiative, too, was thwarted by political events.

At the end of June the Crown Prince of Austria was murdered, and on 2 August 1914, World War I broke out. Since the Smits had Belgian nationality from Henri Smits' side, they were forbidden to leave Haus Meer or to have guests. Lory was isolated from any group-eurythmy work for seven months. She worked daily nevertheless: on poems by Goethe, Uhland and other romantic poets; verses by Angelus Silesius; and poems by Nietzsche.

Clara Smits applied for the family to regain German nationality. In February 1915 this seemed to be within reach, so Lory travelled secretly (without official permission) to Bremen, in order to speak with Rudolf Steiner, who was giving two lectures there. It was their first conversation since January

Elisabeth Dollfus, Annemarie Donath and Lory Smits
(from left to right).

1914, and the first longer conversation that she had ever had alone with him.

First she had to tell him in detail how every single member of the family was. Then she could ask the questions which had accumulated during the lonely months of work. For example, whether the picture which arises in our imagination when a word is heard, can and may be made visible in the gestures. She showed this in a verse by Angelus Silesius: 'God is my staff, my light, my path, my goal, my play.' At the word 'light' ('Licht') she did the 'I' (ee) raying upwards; with the word 'Goal' ('Ziel') she did the 'I' by stretching her whole body forwards, including the leg; and with 'play' ('Spiel') a more casual, sideways 'I' (ee). Rudolf Steiner was very happy with this.

'My youthful wisdom caused me to ask, doubtfully, "... isn't there a danger that it will be too personal this way?" ... "It would be wonderful if it were as personal as possible!" he answered.' She had another question: she had been using 'I—you—he' or 'thinking—feeling—willing' forms for every poem, independently of whether it had free rhythms, fixed verses, or varying end rhymes. Are there, she wondered, different forms for these poetic differences?

Rudolf Steiner barely touched on this. But her questions were answered in detail six months later when he gave an 18-day course for eurythmists in Dornach. For now, she departed from Bremen happy and inspired.

In March, finally, she received a German passport. She travelled immediately to Holland to give courses. In May she went to Stuttgart. We can see from the following little episode just how familiar eurythmy already was to the anthroposophists there: At the wedding of José and Emma del Monte, the telegrams of congratulation were spelled out by Lory silently in eurythmy, and the wedding guests endeavoured to bring all their acquired knowledge to bear, in order to interpret them from the 'visible speech'!

On 15 and 17 June 1915, Rudolf Steiner gave two members-

only lectures in Düsseldorf,[63] 'The Sixth Post-Atlantean Epoch and its Preparation', and 'Experiences of the Human Being after Death'; and a public lecture in which he dealt with the topical theme 'The Driving Force of the German Spirit in the Light of Spiritual Science, with Reference to our Time, in which Destiny Speaks so Powerfully'.

Lory had the opportunity of speaking to Rudolf Steiner and Marie Steiner about her work. (Rudolf Steiner and Marie Steiner had married in December 1914.) 'This one occasion did not go very well,' Lory wrote later. 'I had been working with Goethe's *Mahomet's Song* during the lonely months:

> See the rock spring
> shining clear
> like a star's glance;
> over cloudbanks
> kindly spirits
> nourished his childhood
> twixt the cliffs and in the bush!
> Youthful fresh
> he dances from cloud veils,
> rains down on marble rock,
> leaps up again joyfully
> towards heaven...[64]

For the second verse I had chosen an unwinding spiral, to make it as "youthful and fresh" as possible; I started with a *single* turn but [...] already Rudolf Steiner was interrupting me very energetically: "Now you too are starting to fall prey to this bad habit and showing yourself from behind! That is utterly impossible, you must never do that!"

'He went on about this lack of style, of "wanting to be modern", which had been recently introduced to stage performances. How taken aback and perplexed I was not long afterwards in Dornach when he was directing us in forms for Christian Morgenstern's *Swallows*[65] and at the line "short, swift curves..."[66] told all 10 of us swallows to run to the back

Seven-part rod exercise; Elisabeth Dollfus and Lory Smits (right).

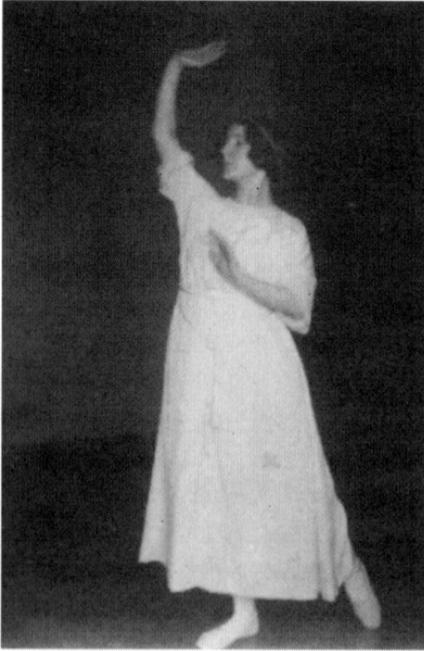

Elisabeth Dollfus, 1913.

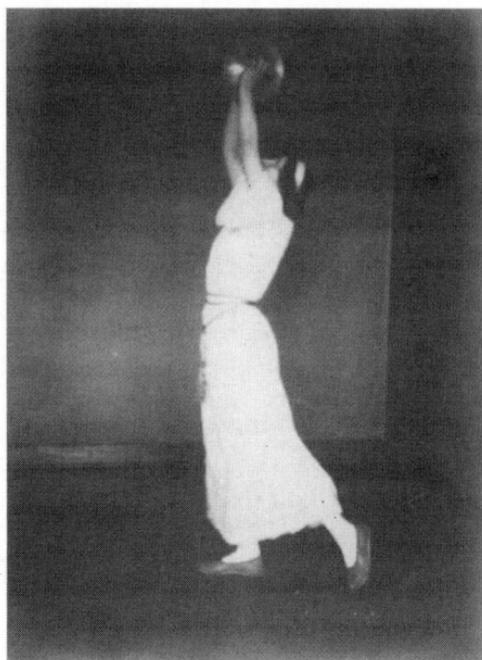

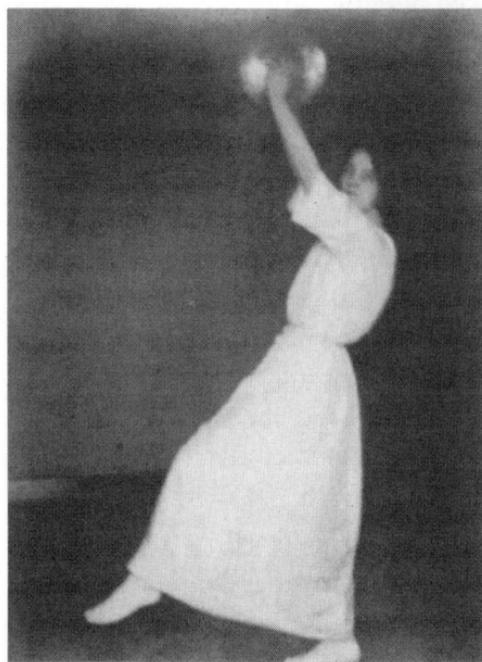

*Lory Smits with cymbals
at Haus Meer, 1913.*

of the stage—with our backs to the audience! And later when we portrayed crows in Nietzsche's *Lonely*[67]—right from the beginning we were to stand with our backs to the audience, doing all of the sounds behind us! Only at the third time that he told us to turn our backs to the audience, for the refrain in Nietzsche's poem *The Poet's Calling*,[68] did I think I understood the principle. The refrain goes, "Yes, my sir, you are a poet, shrugs his shoulders, the bird Woodpecker!"[69]

But for the moment Lory was distressed by her mistake. She reflected that some of the participants had been seen from behind in the Dionysian circle dances. But she felt, too, that this was not comparable to the Goethe poem. Six weeks later she received an answer; it was the Apollonian element in eurythmy which had announced itself.

An important event within Rudolf Steiner's work in the arts had come after the summer drama festival. On 20 September 1913, the foundation stone of the Goetheanum building was laid. All forces were rallied so that the building could become a reality. Rudolf Steiner had to be in Dornach often, so a second centre arose there in addition to the centre in Berlin. The roofing ceremony for the huge wood construction took place on 1 April 1914. Now the contouring of the pillars and walls of the inner rooms could begin.

The outbreak of the war slowed the work but did not interrupt it. The development of eurythmy, however, was seriously endangered. Lory could not teach at all anymore; and the other teachers in Germany were also hindered by the war from teaching and spreading eurythmy. Marie Steiner decided to help. She had seen the new art arise in Bottmingen, she had given it its name, she had followed attentively the first steps of the young teachers. Her great interest in eurythmy came especially from the fact that she had been seeking for many years for the same creative source for the spoken word, that eurythmy must seek for visible speech.

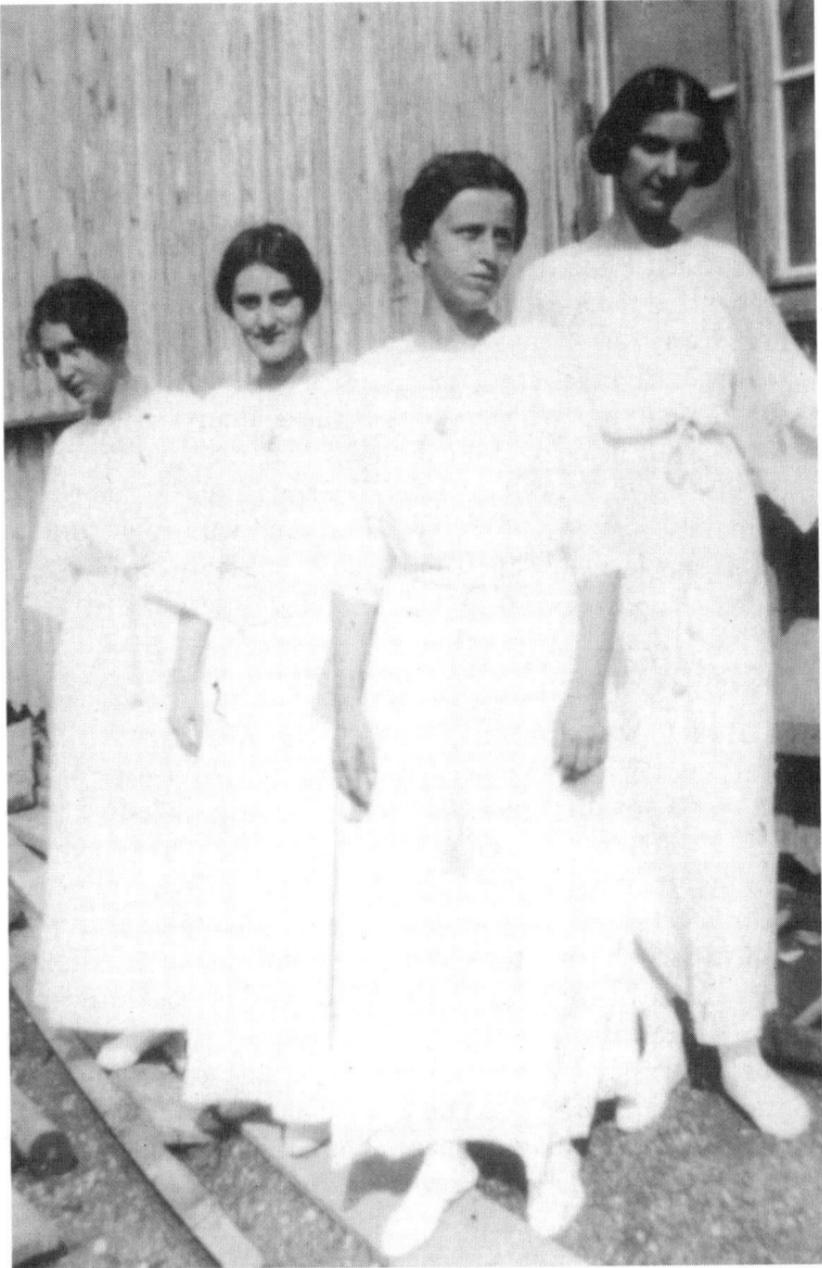

The four teachers Elisabeth Dollfus, Lory Smits, Erna Wolfram and Tatjana Kisseleff during the Apollonian course in Dornach, 1915.

In her forward to the book *Eurythmy as Visible Speech*, Marie Steiner wrote,

> ... In order to save the new art and to wrest its practitioners from their enforced inactivity it became necessary for me to assist them. This task approached me as if predestined, as if self-evident, for eurythmy demanded a new kind of recitation which I had to discover and which I had to develop. I recognized the great importance of eurythmy [...] for all the arts; I was sorry that the zeal of the young ladies should lie fallow during the years of the war. There was no better cure for contemporary aberrations in taste than this new art, which leads us back to the primal forces, the creative forces of the world. Eurythmy was a tremendous blessing for humanity; so for half the year I worked with some young ladies in Germany, the other half at the Goetheanum in Dornach—always supported and encouraged by Rudolf Steiner, whom we were allowed to approach with all of our questions.

And Rudolf Steiner responded to every question with new indications derived from his spirit-illumined creativity. He responded with tone eurythmy to the question about movements for music: 'eurythmy as visible song'. Innumerable questions about individual poems led in the course of the years to nearly 600 choreographic drawings by him, for large groups as well as for soloists. He gave directions for special details, for precise finger or foot movements, and also for costumes and coloured lighting.

The cultivation of this wealth and the safeguarding of its continuity rested from then on in the hands of Marie Steiner. She made sure that the original impulse was kept alive. When Rudolf Steiner founded the 'School of Spiritual Science' in 1923, he entrusted her with the leadership of the 'Section for the Arts of Eurythmy, Speech and Music', which she continued until her death in 1948.

Marie Steiner began her own eurythmy studies in the

summer of 1914. She was living in 'House Hansi' in Dornach and she asked Tatjana Kisseleff to come to her in the mornings. Sometimes Rudolf Steiner came as well, observing and giving further indications. Tatjana Kisseleff had completed a study of law in 1912 in Munich. She had been among the 'luciferic thought-beings' and the 'sylphs' in the third and fourth mystery dramas. She asked Rudolf Steiner how she could best serve anthroposophy, expecting him to give her a task in which she could apply her career qualifications. But to her great surprise he advised her to devote herself to eurythmy. Once she had attended the training course in 1913 and contributed to the performances in Cologne and Berlin, Marie Steiner suggested that she give courses in Dornach. She took up this suggestion with enthusiasm.

After the finishing ceremony of the Goetheanum building, the largest room in the carpentry shop was no longer needed, so it was transformed into a lecture room with a simple stage. There she began—in accord with Marie Steiner's own initiatives—to direct small eurythmy presentations using gifted people from her courses (individual scenes from Goethe's *Faust I*).

7.
August 1915. Rudolf Steiner gives 18 lessons to develop eurythmy

The last scene of Act Five of *Faust II* was planned for 15 August 1915. Marie Steiner invited Lory Smits, Elisabeth Dollfus and Erna Wolfram, the three eurythmy teachers who were working in Germany under such difficult conditions. They beheld with wonder the huge building and the artistic productivity going on in Rudolf Steiner's presence. Many members of the Anthroposophical Society were there helping with the great building task, each according to his or her ability, even though they came from countries which were otherwise at war with one another.

As a preparation Rudolf Steiner held two lectures on 'Faust's Ascension'.[70] Lory took on the role of Maria Aegyptiaca.

Although it was only a small group of Marie Steiner and six eurythmists (the three German eurythmy teachers and Tatjana Kisseleff, Mieta Waller and Alice Fels), Rudolf Steiner gave an extremely rich and varied course from 18 August to 11 September 1915, which he called 'Instructions for how the soul can form speech in movement'. In later years it was referred to as the 'Apollonian Course', in contrast to the 'Dionysian Course' in Bottmingen. (Rudolf Steiner gave these two concepts from Greek mythology only later, in connection with his observations on Nietzsche's book *The Birth of Tragedy out of the Spirit of Music*.) Lory said that she saw the Bottmingen course in a new light when she attended this course of 1915 and later the lecture cycle *Eurythmy as Visible Speech* in 1924.

Whereas in Bottmingen forms were given for all that springs from within the human soul (out into the circumference and

the future), in Dornach forms were given for all that can be described as coming from our surroundings, from the past, from what is finished: nouns, which express concrete or abstract things; verbs, which show whether a process is active, passive or ongoing.

Lory received comprehensive answers to questions that she had put in Düsseldorf. These gave her a basis for developing forms for paired, crossing and enclosing *rhymes; sonnets; ghazels; assonances;* and *alliterations.*

There were *geometrical forms:* triangles, squares, pentagrams, pentagons, and on up to octagons. These were given as a basis for handling verse forms of three to eight lines, and were intended to call up a clear, crystalline-transparent feeling when seen in eurythmy. Lory reported, for example, that they were asked to move along the lines of pentagrams and pentagons with great precision at high speed. 'Spurring us on, Rudolf Steiner called out, "Now I am mixing you all up amongst each other!", clapping his hands rapidly—and one after the other we each ran like a flash of lightening to our next position. It was intended that the audience should experience the image of a crystal, with all its lines of force.'

There followed group forms which allow the mood of a poem to arise even before it begins: merry, tragic, serious, and cosmic preludes.[71]

A great wealth of further indications was given: for performing specific poems, for *foot* and *head positions,* for movements which express colour.

Rudolf Steiner's most beautiful gift, his greatest one to the participants (and to all eurythmists and audiences who have seen it and will see it in the future) were the twelve verses of seven lines each created by him, called *Twelve Moods.*[72] Just as he had described in Berlin in 1914[73] how forces of the stars and planets can have their effect on human thinking, so he now showed how these forces and their relationships to one another within the human soul can be made visible through eurythmy.

This eurythmy course received a special festive note from

the fact that it was the first course ever to be held in the
Goetheanum's 'White Room', which had been quickly fin-
ished just in time for it. Alice Fels wrote:

> The 'star' words of every single line resounded [...] in a
> powerful heavenly symphony [...] when Rudolf Steiner read
> the *Twelve Moods* for the first time in the white South Room
> of the Goetheanum, whose maple and birch panelled walls
> and ceiling provided a unique acoustic sounding board; the
> gentle dawning spring mood of the beginning: 'Arise, O
> glow of light...' increasing gradually to the powerful cul-
> mination in the 'Leo' verse, then dipping down into the
> spiritualized quiet of 'Virgo'....[74]

The choreography calls for 12 people to stand facing the
audience in a large circle, representing the forces which have
come into the human soul from out of the cosmos. A radius
made up of seven people representing the planetary forces
moves like the hand of a watch, steadily and quietly around
the circle.

A few days later Rudolf Steiner recited a *satire* for the
surprised eurythmists—a satire of his own *Twelve Moods* in
identical verse form! In it he makes a humorous character-
ization of the aberrations which people can fall into if they push
one of the moods so far into one-sidedness that the connection
with the whole is lost—making fools of themselves. This is
visible in the choreography, which begins like the *Twelve
Moods*; but soon the radius dissolves, everyone staggers
around and no one reaches their goal. Both works were per-
formed (in a very simple form) at the end of the course.

If we compare the course in Bottmingen, which Rudolf Steiner
developed entirely out of the Dionysian element, with this
course in Dornach dedicated to the Apollonian element, we
discover that the fundamental difference of content pervades
even teaching method and small details of outer appearance.

It is characteristic of the Dionysian element that the artistic

treatment of the material is determined by what lives *within* the soul and emerges *from* it. In Bottmingen Rudolf Steiner awakened an inner impulse in Lory. She was to give it form and make it visible independently, out of her own strength and her own imagination. Only when she had asked him, did he suggest two poems. Also, the course took place in a small unimportant room where she could not try out a single step of a spatial form or rhythm.

Characteristic of the *Apollonian* element in eurythmy is that the circumference must be included in every movement. The creative powers which formed the human body give the impulse for forming the gestures. This is as true for a single step backwards or sideways (which is done to express a grammatical form) as it is for depicting forces of the zodiac.

During the 'Apollonian Course' the participants were meant to try out and practise all these new indications, directly from the blackboard into movement, but due to the wealth of material they did not really manage this. For nearly every new form, Rudolf Steiner brought a characteristic poem along as an example. Three stage performances were given within the three weeks of the course. And the eurythmy lessons took place in the most beautiful eurythmy room in the world, and in a building where the most beautiful eurythmy stage in the world was being built!

After her return to Haus Meer, Lory worked in her usual, dedicated way on the new material. In late autumn she went to Stuttgart. There she wanted to apply the latest indications in her courses, especially the exercises which Rudolf Steiner had given as being good for children and young people. She also wanted to work on the new indications for stage work, and she encouraged Annemarie Donath (who had not been in Dornach) and Elisabeth Dollfus to join her there.

Annemarie Donath described those weeks:

... Lory had participated in the course in Dornach where Rudolf Steiner had given the Apollonian forms. And she

wanted to work through all this new material thoroughly with Elisabeth Dollfus [. . .] and me. Mrs Eiffe, an ex-actress, recited for us, and Mrs Behlen and Miss Laval joined us . . .

The house which gave generous shelter to us all belonged to the Maier family. There were four brothers, their mother, and [. . .] their very ill sister. A lively life with eurythmy [. . .] began. We held our actual practice sessions in the hall of the Branch [. . .] but in the mornings and evenings we had discussions about eurythmy, philosophy and anthroposophy—experiencing a wonderful, inspiring sense of togetherness. [The four brothers] outdid each other in originality and kindness.

8.
1917. Lory marries Alfred Maier

Lory had unceasingly devoted her whole being to her great task, ever since that first conversation of her mother with Rudolf Steiner. Now personal destiny knocked on the door. On 1 December 1915, Lory wrote to her mother:

> My dear Mother, you can't be more surprised by what I have to tell you than I myself was, I really did need the whole day to come to myself. Yesterday morning, exactly four years after the morning on which I had to tell you the sad news about Father, Alfred Maier asked me whether 'I could unite my life with his'. I was so terribly shocked and unprepared that I said nothing at all—just let him talk for more than an hour. And it all sounded so good and quiet and well-considered, that my shock soon left me and I felt very happy and light. But I haven't given him an answer yet, and he is so sensitive as to leave me in peace, and will not come for a few days: 'I want to create a situation for you in which you can develop freely', and 'I don't want to intrude on your freedom'...

The end of the letter reads: '... so don't be angry if I now only ask for a quick answer, and again: please, a yes. Send a telegram, won't you? Yours, Lory.'

Clara Smits did not send a telegram. She hesitated. Alfred Maier went to Haus Meer to introduce himself. Then she invited him to celebrate Christmas with them. The two young people had first met in September 1913, when Alfred Maier and his brother Rudolf attended Lory's first eurythmy course and from the first lesson onwards had admired eurythmy—and the teacher.

Lory now entered into contact with a new circle of people and a wide range of new connections. Many an observer who

looked at this relationship superficially might have been surprised: a graceful, temperamental, agile, elegant, cheerful Rheinlander; and a somewhat stocky, thoughtful, taciturn, small-town Schwab with curly red hair. However if one had a longer conversation with him, one noticed that he was intelligent, independent in his thinking, occupied with high thoughts—but that conventional phrases were not in his line. Alfred Maier was born in Schorndorf, a small town among vineyards and cherry trees near Stuttgart. In the words of a cousin:[75]

> My mother and her sister Karoline were married to two brothers. A more or less similar development might have been expected. This was by no means the case [...] In the

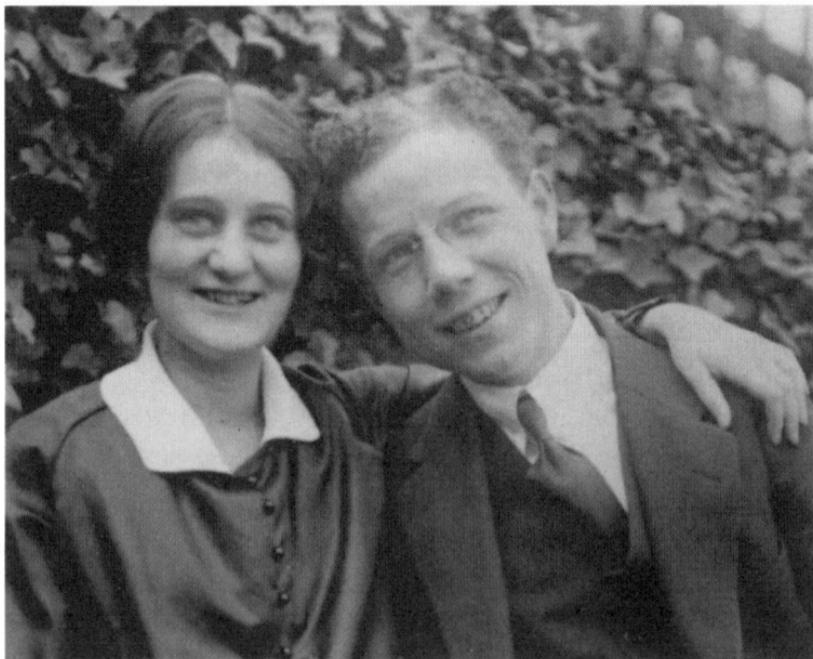

Lory and Alfred Maier-Smits.

parallel family there were eight—six boys, Friedrich, Eugen, Paul, Rudolf, Alfred, Erwin, and two daughters, Helene, Elisabeth. [. . .] From early youth onwards our cousins were industrious people, engaged in practical life and in scientific experiments. While for us [. . .] school studies were in the foreground, *they* were already talking precociously of new forms of perpetual motion machines (at least they were familiar with the problems involved). [. . . they] thought about patents, considered new solutions for technical problems, built machine models. One brother would contribute one idea and a younger or elder brother the other. Early on they revealed a team spirit in the way they went about things. Their destiny of very close mutual work [. . .] led them by turns into heights and depths. As adults they were concerned at first, primarily, with research into dietary physiology. They moved onto the farm Guldesmühle in Härtsfeld. Their efforts in industry [. . .] were based on philosophical viewpoints introduced to them by Rudolf Steiner, which they handled not at all in a dilettante way, but developed with scientific rigour. Energetic Aunt Karoline may have sometimes shaken her head over [. . .] her sons' and daughters'-in-law preoccupation with such a modern form of cultural life. But she stood by them through thick and thin. A separate Forsyte Saga really should be written for this family of highly interesting men and the women who joined them.

Lory was welcomed very lovingly into the Maier family. Her relationship with Alfred Maier went beyond personal affection; it was based on the fact that both of them were wholly devoted to anthroposophical spiritual science. They shared an impulse to do everything they could (in whatever situation life presented) to prepare a space in which anthroposophy could unfold. Their personal way of life, too, was focused on this, in their generously hospitable house in Stuttgart. The Smits brothers had rented the house so that they could attend

lectures at the branch building in Stuttgart (it was not always possible to travel back to Schorndorf afterwards). They had chosen a spacious house so that smaller study groups and other guests could also be taken in.

A picture of the lively anthroposophical life that went on there is given by Hans Kühn, who was stationed with the military police in Stuttgart:

> My wife and I had [...] moved to the house of the Maier-Smits family. [...] Here we took part night after night in lively discussions about all the new anthroposophical lectures, copies of which would swiftly arrive from Dornach [...] We often met friends in this circle, for example Adolf Arenson and his wife, Dr and Mrs Unger, Emil Molt and his wife.[76]

The wedding took place on 31 May 1917 near Haus Meer. The couple then travelled to Hamburg, where Rudolf Steiner was giving two branch lectures and a public one with the theme 'The Immortality of the Soul, Forces of Destiny and the Course of Human Life'. As so often, these themes fitted in well with Lory's situation.

On 5 June 1917 she wrote to her mother:

> ... the Dr [Steiner] days were very good. We were invited to Dibberns for Sunday lunch and the afternoon [...] And at table Dr [Steiner] began suddenly to talk about Father: 'He was a very intelligent man,' he said repeatedly. He had been saying how hard it was for the best minds today to understand the war, and then he suddenly said to me, 'If your father had still been alive, he would have been able'. And then he told how Father always immediately recognized the essentials. He described several examples of this. And how Father had had such a healthy sense for things. That made me so glad. And yesterday evening after the public lecture he came to Alfred and me and said adieu, and several times he repeated that we should send each other good thoughts

*Back row (from left to right): Rudolf Maier, Carl Unger, Lory
Maier-Smits, Alfred Maier-Smits, Hans Arenson, Albert Dibbern,
Hans Kühn, Adolf Arenson, Erwin Maier.—Front row, sitting:
Augusta Unger, Deborah Arenson, Ada Kühn-Honegger, Helene
Moser (born Maier), Gretel Kreuzhage.*

and continue to work together well. And we do want to do
that.—The second lecture was the best one that I have ever
heard. And I hope that it will soon be printed. Similar to the
one in Stuttgart about the age of humanity, but much more
intimate and religious I'd say...

At the beginning of 1918 Rudolf and Marie Steiner travelled
again to Germany. Marie Steiner's energetic work introduced
a new era of eurythmy activity. On February 11 and 12,
Rudolf Steiner held two lectures in Nuremberg. The second
had the theme 'Revelations of the Unconscious in the Life of
the Soul from the Point of View of Spiritual Science'. In it he
also portrayed revelations of the unconscious in the work of
artists. His lecture to the members contained a very exact and

detailed description of the relationship between the living and the dead, explaining the difference between those who die as children and those who die as older people. Marie Steiner had asked Lory to come for a small private solo performance. Marie Steiner recited for it. Lory had prepared Conrad Ferdinand Meyer's *The Ride into Death*[77] among other things.

From 14–19 February, Rudolf Steiner gave four public and two members' lectures in Munich. Marie Steiner arranged for two small private performances with Lory and Annemarie Donath, who was working for the Red Cross during the last year of the war. A public lecture had the theme 'Revelations of the Unconscious'. Two others were called 'Perceptible-Supersensible Reality in its Realisation Through Art'. These lectures contained basic observations about how artistic creativity arises in the human soul and what the soul experiences in naturalistic, impressionistic or expressionistic art. He also spoke of the validity, the limitations, and the possible one-sidedness of individual trends in art. One major statement he made was:

> When we penetrate into nature in such a way [as did Goethe], we arrive at a true reality in a much higher sense than normal consciousness believes. What we arrive at there, however, offers the best proof that art has no need either of merely imitating the sense world, nor of merely expressing the spiritual world—either of which would be to err. Rather, art can give form to, can express, what is of the senses in the supersensible world, and supersensible in the sense world.[78]

Perhaps Lory achieved something of this. Rudolf Steiner surprised her a few days after her portrayal of *The Ride into Death* by saying that she had brought out the 'occult background' of the poem very well.

Albert Steffen, who had attended the public lecture, wrote: 'Present at this lecture were the leading literary and artistic personalities of Munich. Nearly all of them disapproved,

which I could observe from my seat; it was very distressing to me. They were even behaving badly.' And concerning the members' lecture he wrote:

After the audience had already seated itself and the doors were shut, Rudolf Steiner came over to me and started a conversation. 'It is quite, quite impossible to get spiritual science accepted,' he said, mentioning the fierce criticism of his previous lecture in the Munich papers. 'We are facing a terrible collapse.'[79]

This explains why Rudolf Steiner spoke as he did on his last day in Munich, when introducing the eurythmy performance to the members:

It will of course take some time for eurythmists to settle into the work and form it in the way that eurythmy requires. So the current sort of journalism—with all due respect—will rail against them awfully; and I already feel a little concerned about the time when our ladies, who have naturally become somewhat sensitive through the way they live and practise their art, will have to appear in public and be thoroughly reviled. This is inevitable. It is self-understood, for if they weren't, then their art would be worthless [...] As I said, I am already a little concerned—but it must be endured. We have to expect it, that also in this field we will first have to prove our worth by giving performances that are thoroughly criticised. This doesn't have to dishearten us in any way of course, on the contrary, it will stiffen our resolve.

There was a similar combination of lectures, a talk on eurythmy and a eurythmy performance in Stuttgart from 23 to 26 February. We see how carefully Rudolf Steiner prepared the way for eurythmy. In the public lectures this occurred with general observations about the nature of art in the light of spiritual science. To the members he gave manifold suggestions for watching, experiencing and understanding it.

The eurythmists themselves he encouraged and inspired. But Marie Steiner worked with them tirelessly, in Germany and Dornach, spying out every possibility for smaller and larger performances, and taking care of things down to the last detail.

Lory was a very important support among the few more advanced eurythmists. On the day after her 25th birthday, on 7 March, she followed Rudolf and Marie Steiner to Berlin. An intensive time of rehearsal was planned. Writing to her mother on 9 March, Lory thanked her for her birthday greetings and continued,

> Yes, I had an especially nice birthday this year and I must have felt your greetings and thoughts. The day was especially nice and very solemn because Dr Göhrum ascertained that a little person wants to come to Alfred and me in October or November. And I had a long talk with Dr Steiner, who however forbade me almost all eurythmy except for head and arm movements. He said I would do more for eurythmy if I took things very gently now. Frau Dr [Steiner] was naturally a bit sad because of her plans, but she was really very very nice and cordial [. . .] Dr [Steiner] asked right away whether you already knew, and he said you would surely be very glad [. . .] I only hope you are not worried [. . .] Alfred in any case is very happy, to me he seems very glad [. . .] And Father would surely have been pleased [. . .] I still remember how he said once, I should not become a painter, but rather a 'normal woman'.

Lory was in high spirits. She felt fine in the Berlin climate and didn't immediately realise what a decisive effect this was going to have on her life. She went to the rehearsals. She experienced what it was to take part in a group again after the long period of lonely practice, she felt Marie Steiner's powerful artistic impulse, and she saw the difficulties caused by the need to have herself replaced. She wanted to help bridge the gap. Standing only, she helped the others with arm gestures and head posi-

tions. Then someone was missing. Lory filled in for her and practised with them. On 20 March she wrote to her mother,

Yesterday I stepped in for someone who was missing, and although it felt very good for the moment to do more than just 'standing off to one side'—a line which I portrayed with much feeling and expression in the 'elegy', to the great amusement of Frau Dr [Steiner]—it had such a bad effect on me, especially since it was practised again at four in the afternoon, that I didn't go to the public lecture that evening. Dr [Steiner] had already mentioned this possibility, by the way, saying that when he thought of my contribution in *Pentheus* he was very concerned, for such an effort could lead directly to misfortune. Well it went all right, which is also a sign that everything is all right with me. There are supposed to be a number of lectures in the Easter week and also a eurythmy performance. I have to be here for that. Maybe I should do the 'paternoster' as well. That would be gentle enough for me.

And then Rudolf Steiner saw her taking part in a rehearsal. He spoke of it in such a way that she immediately stopped with eurythmy altogether.

It was indeed the first time that a woman who had dedicated her whole body, soul and spirit to eurythmy for six years—thereby letting part of her etheric forces flow into movement—now had to let her forces flow instead into the forming of a body for the incarnation of a human soul. It was also the first opportunity Rudolf Steiner had had to study such an event concretely in someone's supersensible organisation.

Lory returned to Stuttgart. In November her daughter Anna-Sophia was born, in Schorndorf. She was named by Rudolf Steiner.

In November 1918, World War I came to an end. The restrictions of the war ceased, the existing forms of state and social life disintegrated. In this chaotic, but somewhat more

open situation, Rudolf Steiner went to Stuttgart to speak on his ideas of a threefold social order.

The Maier brothers sought ways of working together and of making use of their capacities in applying anthroposophical knowledge to practical life. These efforts had a varied course in the decades to come. There were successes and setbacks, times of steady progress, dramatic crises, tragic conflicts—and Lory was intimately bound up with it all.

In 1919 the Maier brothers bought the farm Guldesmühle, between Neresheim and Dillingen. It had about 200 acres of land, livestock trade, a grain and oil mill; and also a sawmill which enabled them to be active in a technical field. (In October 1920, foot and mouth disease broke out there. Rudolf Steiner gave indications for treatment and Dr Eugen Kolisko innoculated 122 cows at Guldesmühle and nearby. Since he had to act quickly and there were official regulations, there was no basis for an exact scientific evaluation.)

In 1922 Guldesmühle was integrated into the newly founded company Der Kommende Tag, which was structured on the basis of a threefold social order. One of the Maier brothers, the physicist Dr Rudolf Maier, became a member of the board of trustees and also a leader of the Institute for Scientific Research belonging to it. Rudolf Steiner gave him the task of developing an optical effect with an electromagnet, which would allow new discoveries about the limits of the colour spectrum.

The Maier brothers tried to put other indications by Rudolf Steiner into practice in Einsingen near Ulm, where they had begun to manufacture buttons in an old powder factory.

Alfred Maier had experience in making buttons. After his training in business he had once had a leading position in a button factory. (The factory was liquidated when the owner died.) Now he was trying to refine the not so suitable substance of cattle hooves so that it could be used for making buttons.

Lory's brother Henri Smits (who was a mining engineer)

Sonntag, den 14. und Dienstag den 16. September 1919,
um 8 Uhr abends finden statt in den Räumen der Anthro-
posophischen Gesellschaft, Potsdamerstraße 39, 39 a,
Ateliergebäude

Darstellungen

Eurythmischer Kunst

Mitwirkende:

Annemarie Groh, Lory Maier-Smits,
Natalie Papoff, Erna Wolfram
und Andere.

Die der Aufführung zugrunde liegenden Dichtungen
werden von MARIE STEINER rezitiert werden.
Die begleitende Musik ist von Leopold van der Pals
und von Walter Abendroth.

Karten zu Mk. 4.—, 3.— und 2.— in der Geschäfts-
stelle der Anthroposophischen Gesellschaft,
Motzstrasse 17, Grth. II
und an der Abendkasse.

Eurythmy programme from September 16, 1919.

was working with a suggestion of Rudolf Steiner's for using peat-fibres in the manufacture of a specialised fabric.

Rudolf Maier transferred his experiments to Einsingen in 1923, because a large amount of electricity was available there.

Rudolf Steiner's manifold connections to the Maiers can also be seen from the fact that he spoke at the funeral of Elisabeth Maier, who died at a young age on 29 March 1923.[80]

All these hopeful attempts to break new ground would have

needed further advice from Rudolf Steiner. Due to his heavy workload in 1924 and death in 1925 nothing more was achieved in this direction.

At the end of the 1920s (during a general large-scale economic crisis) the firm got into financial difficulties and had to be liquidated. This was an extremely complicated and worrying process.

The Maier brothers had discovered a special method for manufacturing red lead pigments and they now began to make use of it in a small new business in Marktredwitz. When they needed to expand they moved to Hüningen in Elsaß and in 1942 to Laufenburg in Oberrhein. After the war the business was dismantled and taken away in the course of reparation payments.

Lory felt her connection and obligations within this exceedingly turbulent course of events. Nevertheless eurythmy must have kept its priority in her deepest soul.

During the years 1919-1922 she could still visit Dornach for shorter or longer periods and take part in the stage work.

1919 was a time of manifold fulfilment for Lory. During the first months she went to Dornach and took part in Marie Steiner's rehearsals.

On 20 April, Rudolf and Marie Steiner went to Stuttgart. For three months Rudolf Steiner immersed himself in the spiritual battle for the realisation of a threefold social order. He tirelessly gave talks to workers and to the public. He had discussions with workers' representatives, entrepreneurs and politicians.

The eurythmy group, too, was called upon to make great efforts. Marie Steiner organized the first public appearance of eurythmy in Stuttgart, in five major performances. One was given in the regional theatre of Württenberg, another in the domed room of the art building. Another was given for the workers of the Waldorf-Astoria cigarette factory, whose children four months later became the very first Waldorf

DARSTELLUNGSFOLGE

Einleitende Worte
von Rudolf Steiner über eurythmische Kunst.

In eurythmischer Einzel- oder Gruppenkunst kommen zur Darstellung:

Worte an den Geist und die Liebe, aus Rudolf Steiners „Pforte der Einweihung", dargestellt durch eine Gruppe.

Wochenspruch aus dem Seelenkalender, von R. Steiner, dargestellt durch Erna Wolfram.

Das Ewige, von Hans Reinhard, dargestellt durch eine Gruppe.

Die blaue Blume, von M. Kyber, dargestellt durch N. Papoff.

Das Märchen vom Lieben und Hassen und vom klugen Verständ, von R. Steiner, dargestellt durch eine Gruppe.

Auftakt, „Schau in dich, schau um dich", von L. van der Pals, dargestellt durch eine Gruppe.

Irrlichter, von Th. Wertsch, dargestellt durch N. Papoff.

Vorfrühling, von Fr. Hebbel, dargestellt durch eine Gruppe.

Waldlied, von N. Lenau, mit musikalischer Beigabe von Walter Abendroth, dargestellt durch eine Gruppe.

Der Herbst, von Fr. Nietzsche, dargestellt durch L. Maier-Smits.

Einer Toten, von R. Steiner, mit musikalischer Beigabe von Walter Abendroth, dargestellt durch eine Gruppe.

PAUSE

Wanderers Nachtlied, von Goethe, dargestellt durch eine Gruppe.

Auftakt „Evoe", von Walter Abendroth, dargestellt durch eine Gruppe.

Der römische Brunnen, von C. F. Meyer, dargestellt durch eine Gruppe.

Mein Glück, von Fr. Nietzsche, dargestellt durch A. Groh.

Satyrischer Auftakt, von L. van der Pals } dargestellt
Aus den „Galgenliedern", von Chr. Morgenstern } durch eine
Heiterer Auftakt, von L. van der Pals } Gruppe.

Eurythmy programme from November 19, 1920.

pupils. On each occasion Rudolf Steiner gave an introductory talk.

When it became clear in July 1919 that the idea of a three-fold social order was not going to be adopted, Rudolf Steiner concentrated on getting the Waldorf School started.

The eurythmy group gave a matinee in Mannheim on 27 July, and performances in Berlin and Dresden in September. Lory participated in all of these. That year she was living in the

Werfmershalde house in Stuttgart, which stood right between the Waldorf School and the Anthroposophical Society. She had her refuge there among the members of her large family, who admired her artistic work and gladly supported it. And Clara Smits lived there, too, with Lory's sisters Ellen, Ada and Thea, and everyone helped to look after little Anna-Sophia. So Lory was part of a warm and generous family, and simultaneously part of the anthroposophical stream which was flowing into cultural life through Rudolf Steiner. She could attend his lectures, she could take part in the discussions about them, and—most important of all—she could practise at home and in the building of the Branch.

The eurythmy group returned to Dornach at the end of July. On 7 September the Waldorf School opened. The opening ceremony took place in the large hall of the Stadt-garten. The programme included some eurythmy, performed by Lory Maier-Smits, Elisabeth Dollfus and Mieta Waller (and Thea Smits). On this memorable day Elisabeth Dollfus married the composer Paul Baumann. She was to be the first eurythmy teacher at the Waldorf School. Paul Baumann was engaged as its music teacher. (That same year Edith Röhrle and Nora Stein von Baditz came to help with the rapidly growing number of children.)

After that Lory retired to the Guldesmühle farm. In August 1920 her second daughter Johanna Maria was born. She, too, was named by Rudolf Steiner.

Kasinosaal Freiburg i. Br.

Freitag, den 19. November 1920, abends 7 ½ Uhr

VORFÜHRUNG IN EURYTHMISCHER KUNST

ausgehend von der Freien Hochschule für Geisteswissenschaft
«Goetheanum», Dornach/Schweiz

Mitwirkende: 12 Kinder von der Freien Waldorfschule Stuttgart
Frau Elisabeth Baumann, Frl. Edith Röhrle, Frau Lory Maier-Smits,
Frau Alice Fels ... und andere
Rezitation: Frau Marie Steiner Gesang: Frau Olga Leinhas
Klavierbegleitung: Paul Baumann

Einleitende Worte von Dr. Rudolf Steiner

I

Waldesnacht (eine Kindergruppe) Paul Baumann
Meeresbrandung. Eine Elementarphantasie
 (L. Maier-Smits) Christian Morgenstern **X**
Die Enten laufen Schlittschuh (eine Kindergruppe) . . . Christian Morgenstern
 mit musikalischer Beigabe von L. van der Pals
An die Cikade (I. Bögel) J. W. v. Goethe
Kleine Geschichte (eine Kindergruppe) Christian Morgenstern
Haschemann (eine Kindergruppe) Robert Schumann
Heideröslein (E. Baumann und L. Maier-Smits) J. W. v. Goethe **X**
Die Freuden (I. Bögel) J. W. v. Goethe
Goldne Wiegen schwingen (Laut- und Toneurythmie,
 dargestellt durch Kinder der Waldorfschule) Paul Baumann
Kleine Ballade (eine Kindergruppe) Ernst Moritz Arndt

II

Was treibst du Wind? (E. Baumann und L. Maier-Smits) C. F. Meyer **X**
An Schwager Kronos (E. Röhrle) J. W. v. Goethe
Schwellengang (eine Gruppe) B. von Polzer
Bittendes Kind (Toneurythmien, dargestellt durch
 Kinder der Waldorfschule) Robert Schumann
Nachtlied (E. Schilbach) Friedrich Hebbel
Volksliedchen (Toneurythmie, dargestellt durch
 Kinder der Waldorfschule) Robert Schumann
Herbst (L. Maier-Smits) Friedrich Nietzsche **X**
Auftakt «*Schau in dich, schau um dich*» (eine Gruppe)
Zwiegespräch (E. Baumann und L. Maier-Smits) C. F. Meyer **X**
Schön Blümelein (Laut- und Toneurythmie,
 dargestellt durch Kinder der Waldorfschule) Robert Schumann
Mahomets Gesang (E. Röhrle) J. W. v. Goethe
Salome (E. Baumann) Manfred Kyber
 mit musikalischer Beigabe von Paul Baumann

9.
1920–1922. Lory's contribution to stage eurythmy

Since Lory knew her two little daughters to be lovingly cared for by their grandmother Clara Smits and the rest of the family, she was able to devote herself wholly to eurythmy in Dornach, from November 1920 to 1922. There she was most welcome. Other young ladies were of course active there, but Lory had the most experience. Her own particular dedication, thoroughness and persistence in working with Rudolf Steiner's indications set an example, and her enthusiasm was inspiring. Not the least, she had a large repertoire of lyric, dramatic and humorous poems. Some of this repertoire can be seen from the programme of the Freiburg performance on 19 November 1920 (see p. 125).

A few of the things that happened during this time in Dornach follow.

Lory was working on one of Nietzsche's most beautiful poems, *Declaration of Love*,[81] which concerns the flight 'like star and eternity' of the albatross. It ends:

> O bird, O Albatross!
> To the heights am I drawn eternally.
> I thought of you: then flowed
> Tear after tear—yes, I love you![82]

Rudolf Steiner saw it at the rehearsal and was satisfied, and wanted her to do it at the next performance. But then he said, 'Only one thing was missing,' and he pointed out the subtitle in small print: 'during which the poet, however, fell into the hole.' Rudolf Steiner had drawn for her a 'Nachtakt':[83] she should keep the poem as she had worked it, 'and [...] when you have paused for a moment in the last position, suddenly add this silent Nachtakt.'

The last position was stretching high up, full of devotion to the stars and eternity. Now came the Nachtakt: an angular form with sudden changes of direction. Next to it was a sketch of a little figure whose upper body was bent almost at a right angle forwards, with arms withdrawn to head level. And the whole form should be danced in this position.

So I practised diligently, but at the dress rehearsal it happened nevertheless that while I was attempting to leave the stage backwards, I sat down in the middle of it. Rudolf Steiner liked that so much that I now had to practise the sitting as well, and remain there until the curtain closed. Then we went on tour with the programme, and I sat down in the middle of the stage in Dresden, in Leipzig, in Halle and finally in Berlin. In Berlin there was spontaneous applause....

Another (this time accidental) occasion of sitting down elicited thunderous applause. It happened in Goethe's poem *Séance*:

> Tis here that, each under his own name,
> the letters to assembly came.
> With coloured veils and coloured dresses
> each vowel to the front seat presses,
> A, E, and I, and O, and U,
> making a huge hullabaloo.
> The consonants arrived stiff-kneed,
> for entry-permits had to plead.
> President A them nicely greets,
> so they were shown into decent seats...[84]

Here, it happened. Ilse Baravalle and I were the consonants S and L, and with utterly stiff knees we had to follow a wavy form right across the stage—one from the right, the other from the left [...] At the performance our legs got tangled at 'So they were shown (crash bang) into decent seats' (thunderous applause). We both jumped up and went on with the poem. Backstage we talked about what had happened and

laughed gaily, and Rudolf Steiner joined us, laughing loudly and heartily: 'We shall never be able to perform it again. The audience will rightly demand that you do it that way again. How you fell! It was just one crash and at the perfect moment! How you jumped up and went on, everything in unison! And that symmetry! It was marvellous! That symmetry!' At that point I said somewhat pitifully, 'But it wasn't completely symmetrical, because nothing happened to Ilse, but I sprained my thumb.'

At once Rudolf Steiner examined the thumb and asked someone to bring arnica, a quarter-litre of water, and an elastic bandage. First he very carefully counted out some drops, then he wrapped my hand so that the thumb was fairly tightly bound. 'It will be a little unpleasant the first day, especially tonight, but it must be so. I have to constrict and cram in all the healing forces there. Tomorrow evening come again and you will get a new bandage.' I was allowed to come for several days and each time the thumb was treated with the same care and kindness. Once, too many drops fell into the water. Herr Dr [Steiner] called for fresh water and made the mixture afresh ...

One evening my thumb was treated as usual. When he was finished, he looked at his work again—and found that it was not beautiful enough: 'An elegant lady must also have an elegant bandage.' He undid it again, and I received an 'elegant bandage'.

A further experience that Lory had during the Dornach rehearsals will be mentioned here because it shows her extraordinary ability to practise methodically. She was willing to identify herself with the task or character selflessly—indeed even to the point of self denial—to practise until even the last spark of vanity or self-enjoyment had been purged away. Since she practised every detail to perfection she was able, at the end, when looking back over the whole, to give each detail its due value.

One day [...] Marie Steiner brought a [...] form drawn by Rudolf Steiner for 'The Hystrix' from Christian Morgenstern's *Gallows' Songs*:

'The Hystrix'

The hither-Indian porcupine,
(hystrix grotei Grey)
the hither-Indian porcupine
from Siam, spoils your day.

If you in forests roam about,
in Siam, on his trail,
he'll step, they say, at times right out
of Nature's boundaries frail.

His anger makes him then so bold
that, while your eyes you blink,
his quills he will, both young and old,
into your body sink.

From top to toe you now are quite
pinned fast against the tree,
as Saint Sebastian a sight
that who believes may see.

The Hystrix, though, away will creep,
in soul and body bare.
And sits alone in jungles deep,
in prayer.[85]

She asked me if I wanted to try it. Besides very interesting forms there were exact [...] indications noted on the pages: 'The whole poem is danced with the feet turned inwards and the legs are often crossed in E (ay). Also the upper body is rocked from left to right and from right to left. The head is frequently shaken like a top.' I was of course very enthusiastic and started work on it with great pleasure. But my pleasure soon vanished, replaced by a truly horrible

experience. Already by just following the [. . .] indications—feet turned in and legs crossed in E (ay)—one had the feeling that one's arms were becoming long, heavy and unfree. One's human uprightness was lost! And when the swaying of the upper body and the shaking of the head like a top were added, the human form was destroyed, extinguished—transformed into its opposite. It was [. . .] an animal standing there! Even the shape of my face felt transformed—I had no mouth anymore, my lower jaw jutting forward turned it into a snout [. . .] I would start to foam at the mouth at any moment! The transformation of my face was especially awful, and I looked through all the indications and drawings again. And what did I find?—'With a blue veil thrown over the head . . .' Rudolf Steiner had seen in advance that it would be necessary to throw a protective veil over that all too coarse apparition. Really, it would not have been possible without that veil. But [. . .] there was something else there as well that I had not read at first: The swaying back and forth of the upper body and the shaking of the head should be left out of the last line and the entire Nachtakt, so that a subsiding of the 'inhuman' quality and a certain return to form and measure were already built in. The longer I occupied myself with this task the more I realised that in the end it could only be mastered with humour.

Rudolf Steiner had recommended humour to us as a necessary tool for every artist. He once told a painter that it was a force in our souls which transcends our lower nature. He himself portrayed it artistically in its highest form as a being called 'Cosmic Humour', which he included in his great wood sculpture of the 'Representative of Man'.

During this period Rudolf Steiner gave indications and choreographic forms for many poems. Many of them were first performed by Lory.

This intensive rehearsal and performance work, which still had pioneer character, was suited to Lory's being and ability.

Nevertheless, she was homesick for her family, especially her two little daughters. She had a long talk with Rudolf Steiner, and from the way in which she did not want to speak of it, one could sense that this talk had been a great help to her in making decisions about her further life. In 1922 she gradually withdrew from the Dornach eurythmy group.

In December 1923 Lory and Alfred Maier-Smits went to Dornach for the Christmas Foundation Meeting, where Rudolf Steiner refounded and renewed the Anthroposophical Society.

From 24 June to 12 July 1924, Lory attended Rudolf Steiner's speech-eurythmy course. It may have filled her with painful melancholy that she now sat in the audience and was no longer part of the eurythmy demonstrations, but on the other hand it did allow her the comforting impression that many eurythmists were enthusiastically working to further what she had begun.

10.
1923–1958. Lory in the circle of her family

The Maier brothers had begun building up their company in Einsingen in 1922—in the middle of the worst inflation. There Lory was far away from any shared eurythmy work. Marie Steiner did send her a few young women interested in a eurythmy training, so a small intensive training course began. Lory also gave courses for adults and children in Ulm and a course for people working in the family business.

When Marie Steiner set up the 'Eurythmeum' in Stuttgart in 1924, as the first authorised training institution, with a curriculum and many different supporting subjects (and its own building designed by Rudolf Steiner), new courses begun by Lory were no longer possible. She let her abilities flow more and more into devoting herself to the truly complex family business and communal family life.

We have the most vivid description of this thanks to Margarita Woloschin. As a Russian with a Soviet passport she was ordered to leave Switzerland in late Summer 1923. She was unhappy and at a loss: 'The earth has no place for me.' After much effort Lory was able to get her a visa for Germany.

Margarita Woloschin went to Stuttgart first, where she was received by Clara Smits at the Werfmershalde house. 'How strange it seemed to live again in a big middle-class house with lots of rooms and old furniture,' she wrote. Clara Smits told her enthusiastically that her son-in-law Alfred was trying to build up a cultural centre in Einsingen, and Lory was giving eurythmy lessons to a group of young girls. They were painting and playing music, studying Schiller's *Aesthetic Education of Man* and Rudolf Steiner's lectures. Margarita Woloschin was excited about going there.

It was on a comfortless, dark, rainy day in September that I

was driven by car into the yard of the factory in Einsingen. Low barracks and flat buildings surrounded it, only the two-story office building with its workshop and machine room projected above them.

I immediately noticed a strong, unpleasant smell like burnt bones. It was always fouling the air, as I soon found out: for button production, cow horns have to be softened by heating, so that their spiral structure can be flattened.

The living quarters were set up in ex-factory rooms and at first they made a dull impression. The large dining-room, however, with its warm red walls and the black furniture, seemed very comfortable and inviting. In a corner stood a round table with red armchairs around it. Lory said, 'I've always thought that you would sit in this corner one day and talk'. How thankful I was at that time for those words!

Excepting Lory, the people into whose circle I now came were totally unknown to me. Only her husband Alfred Maier I had seen briefly before. I learned to value him very highly. If he spoke with someone, it was always with warm interest. Of the five brothers whom he still had, probably his brother Rudolf was closest to him. One could often see these two walking back and forth for hours talking. Productive ideas for the work arose from these intense conversations.

A third brother, Erwin Maier, also a physicist with creative talent, was married to Lory's sister Ada. And the fourth, Eugen Maier, had graduated from the school of civil engineering. He was extremely gifted with machines. In the evenings, when the four brothers sat at the round table in the dining room and put their big heads together, a cloud of tobacco smoke and coffee steam formed above them. Ever new ideas and ingenious solutions to their manifold scientific and technical problems were born in that corner.

Lory devoted much time to training five young eurythmy students, but she was also occupied with the business worries of her husband and his three brothers.

I also got to know Lory and Alfred's two children, the 5

Lory Maier-Smits with her daughters.

The factory grounds at Einsingen.

year-old, very blond and blue-eyed Anna Sophia, and the 3 year-old somewhat darker Johanna Maria. Both were distinguished by untamed curly hair raying outwards into the cosmos, and an equally unconstrained vitality and energy. They were taken care of by a governess from Berlin, who later became a fine eurythmy teacher in Wuppertal.[86]

Rudolf Maier and his assistant Hans Buchheim had been working on ways of influencing the colour spectrum with a magnetic field. They had been wrestling with this for a long time, when one October day it seemed to actually succeed. Rudolf Maier let Rudolf Steiner know by telephone. Rudolf Steiner, who was coming to Stuttgart anyway, decided to make a detour to Einsingen to see it for himself.

> On the evening of that day, at about 11 p.m., the car with Dr and Frau Dr Steiner arrived. Dr Steiner wanted to see the experiment immediately, even before the evening meal, and he went with the men to the machine room. After a while they came back and Rudolf Steiner, who seemed very gay, said, 'Einsingen will become famous through this experiment! This success is the first link in a long chain!'

There followed an evening meal with happy personal conversations that went on until about 2 a.m. The next morning at 5.30 a.m. they were all together again for breakfast, also the children. Then Rudolf Steiner wanted to see the experiment again. Everyone went along, and they each had to have a look through the small hole of the experimental contraption and describe what they saw. Afterwards they spoke about button production, and Rudolf Steiner made a note of the problem of how to refine the much less suitable, but much cheaper, hoof material. 'Come to Dornach, I will tell you exactly how to do it,' he said.

The car was waiting. He said goodbye to everyone. He wanted to visit the morning lessons at the Waldorf School in Stuttgart.

An especially close relationship arose between Lory and the governess from Berlin, Johanna Otto. Johanna reports on something that many others have also experienced in encountering Lory. It must have lain in Lory's destiny to meet people who were unconsciously open to, and searching for, eurythmy. When they met her, they realised what they had been seeking. That happened with young girls who then became eurythmists; it happened also when she was over 60 years old and visiting a Waldorf School. As she told about the beginnings of eurythmy, the Upper School children in her audience realised that they loved it.

Johanna Otto had come to Einsingen in 1923, without ever having heard of eurythmy. She began doing it in the little training course. When the two daughters went to Stuttgart to attend the Waldorf School she went with them to the Werf-mershalde house, and finished her training at the Eurythmeum with Alice Fels. Then she gave courses in Düsseldorf, and after World War II she became a eurythmy teacher at the Waldorf School in Wuppertal.

It is sixty years since I left home to learn and gather experience. Without money and without a clue as to what I could do, I went away—I sought—and I found. And what did I find? A person whom I could love and revere; I came to the house of Lory Maier-Smits. She needed help with her two daughters, who were 3 and 5 years old. And then followed years in which I received much more than I was able to give. Already after a few weeks, I was allowed to take part in the eurythmy lessons in my free time [. . .] I had never heard of it and I was entranced by the beauty I now experienced.

I had already got to know Lory Maier-Smits as the ready helper of her husband, as a loving mother and as an understanding employer. Now I was to experience her as a teacher of the new art, eurythmy, for whose sake she had offered her services to Rudolf Steiner. What was it that I learned from her? A genuine, in the truest sense childlike

devotion to movement; a total willingness to make Rudolf Steiner's indications her own and bring them to realisation. And she expected from us that we practise with the same devotion—make ourselves capable of letting the Genius of the language become movement. Rarely did she scold us, but she always provided inspiration. She never lectured. She herself was unbelievably beautiful in movement—Dionysian, like a Greek. Conversations with her were also questions to the future: What will eurythmy become?[87]

This question, which has been relevant from the beginning of eurythmy until today, became a personal one for Lory from 1925 onwards. She still gave a few eurythmy courses within the community in which she lived, but she renounced all outside eurythmy work. However, she kept and cherished the eurythmy impulse within her.

But her so valuable ability to concentrate, her persistence, her selflessness and her inner mobility she dedicated to the social and cultural tasks invoved in the daily running of the complex family business.

Once a month Dr Eberhard Schickler came to Einsingen from Stuttgart. Every member of the company who wanted to could consult him free of charge. Afterwards the women of the family (Olga Smits, married to Lory's brother Henri, her sister Ada Smits, married to Erwin, and Lory herself) saw to it that the medical advice was carried out. Each year the Oberufer Christmas Plays were performed for the people in the company and the nearby villages. There were groups which studied Rudolf Steiner's works. The garden was worked biodynamically, following the principles given in Rudolf Steiner's 'Agriculture Course' in Koberwitz a short time before.

In 1928 a third child was born to Lory and Alfred, their son Johannes Immanuel. Their two daughters attended the Waldorf School in Stuttgart, where they were looked after by Johanna Otto, with whom they had a very warm relationship. The children spent their holidays in Einsingen.

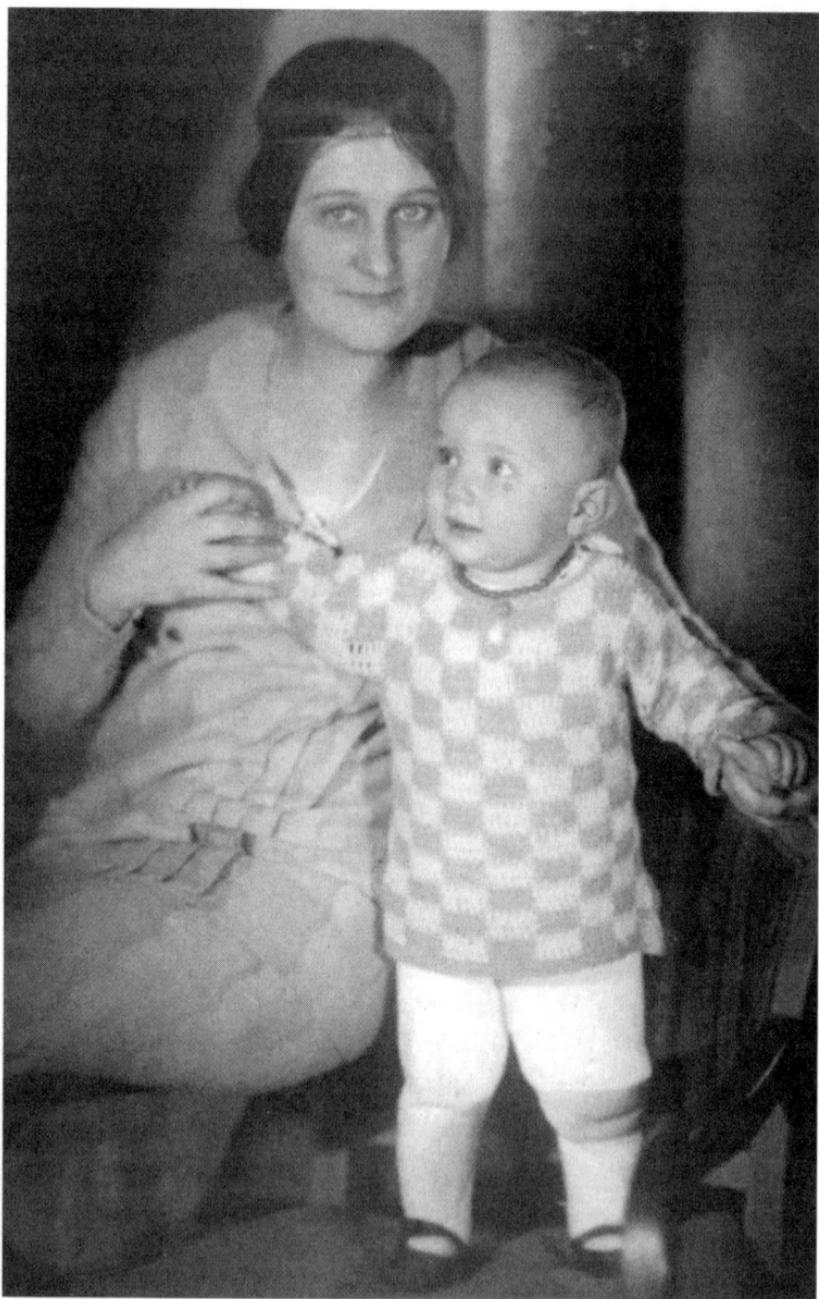

Lory Maier-Smits with her son Johannes Immanuel born in 1928.

When the business had to close in the 1930s, there were complications and difficult conflicts for everyone involved. During the following months and years of worry and renunciation, Lory was a centre of peace. Her natural discipline, increased by eurythmy practice, and her tolerance and kindness, enabled her to hold her ground during the time of trial. She continued to forego all eurythmy.

But there were not only personal and economic worries to be dealt with in those years. Even more oppressing was the political situation, which led to the prohibition of the Anthroposophical Society in Germany and gradually to the closing of all of the institutions which had arisen out of the impulses of spiritual science (e.g. the Waldorf School in 1938, the Eurythmeum in 1941).

In 1931, the time of the worst economic crisis, the Maier brothers had to create a new means of existence for themselves. Thanks to their gift for inventing, this succeeded. It began with experiments at the Werfmershalde house, which then were followed up at a small factory in Marktredwitz (lead pigments). Lory remained with the children in Stuttgart. In 1942 the business was moved to Hüningen in Elsaß, where the family joined them. In 1943 Alfred's closest brother, Dr Rudolf Maier, died there of heart failure. That year they moved to Laufenburg/Oberrhein, where they were when World War II came to an end.

The Werfmershalde house was destroyed by bombs shortly before the end. It had served for many a secret meeting during the time that the Anthroposophical Society had been outlawed. Moving memorial celebrations for soldiers fallen in the war would remain in the memories of the participants. People who had lost their homes in the bombings found shelter there for shorter or longer periods.

It was the house in Laufenburg that was now always open to guests. Lory and Alfred remained true to the impulse that they had shared from the beginning as a newly married couple: to create a space and mood conducive to cultivating anthro-

posophy for as many people as possible. Johanna Otto reported:

> Shortly after the end of the war, when I could finally go to Dornach again, I made a detour to Laufenburg on the way back. Although I appeared unannounced at the door I was immediately included again, and I found a large circle of friends who had gathered there during the war and afterwards.[88]

Margarita Woloschin and her brother Alexej Sabaschnikow and the Krücks from Poturzyn were all there. The ex-Waldorf teachers Karl Ege and Margarete Dähnhardt had found their way there in 1944. Since at the war's end governmental controls were loosening, they made use of the opportunity to teach a group of 15 to 18 children along the lines of Waldorf education, which was still forbidden. Up until 1948 Karl Ege taught the Main Lessons, Margarete Dähnhardt the foreign languages, and Irmela Beck-Vogel came every week from Säckingen to teach eurythmy. Lory always watched these lessons with great interest. She observed tone eurythmy with special attention, whose development after 1922 in Dornach she had not experienced. She did not feel inclined to teach these children herself. She revealed her extraordinary mobility (as a 52 year-old) only to her grandchildren—giving them demonstrations of a variety of gymnastic exercises, including the 'big circle', on the horizontal bar! But she did invite young women in whom she detected a gift for movement, and others requesting it, to attend intensive eurythmy lessons.

As it gradually became possible to travel again after the war, Lory watched eurythmy performances in Dornach whenever she could. Since the building had not yet been reopened, these performances took place on the stage in the carpentry building. With her wakeful sense for art she observed how much further eurythmy had been developed since the 1920s.

In 1948 Clara Smits passed through the gate of death.[89]

It must have been in January 1949 that Lory saw a guest

Alfred Maier-Smits.

performance in Dornach by the group led by Else Klink. Else
Klink and Otto Wiemer had been given the leadership of the
Stuttgart Eurythmeum by Marie Steiner in 1935. After the
Eurythmeum was outlawed in 1941 and the building
destroyed, an interim institute arose under the name
'Eurythmy Conservatory Köngen on the Neckar'. The per-
formance of this group included a piece developed along the
lines of a Dionysian circle-dance based on 'you' forms. Lory
went backstage after the performance, her profound emotion
bringing tears to her eyes as she spoke of this piece. She went
on to tell with radiant eyes how these forms had been intro-
duced by Rudolf Steiner in 1912. On the spur of the moment
Else Klink invited her to come to the students and tell them
about those early days. Lory agreed, and came. Ruth Vogel,
who was in the second year of the training at the time, wrote:

> Long before she entered the room it was already quiet. We
> had a great sense of expectation: how will she look? [...]
> How will she move? ... the first eurythmist?
>
> Then Else Klink and Otto Wiener brought her in: of
> middle height, slim and delicately boned—a delicate,
> attentive face, strong chin, long, expressive hands, a tight
> grey costume which made her appear stern. She looked at us
> in an open, friendly and intense way. Then she talked for a
> long time—very animatedly and full of atmosphere, again
> and again making or indicating wonderful gestures for the
> sounds—about how she had been permitted to experience
> the beginning of eurythmy...'.[90] The listeners were
> enchanted, elated, elevated.

Lory could not accept a later invitation for another visit.
Her husband's ill health required total seclusion as she
dedicated herself to his care.

Alfred Maier passed through the gate of death on March
16, 1958.

11.
New work in eurythmy

After the death of her husband, Lory felt that free space had
become available for eurythmy. She joyfully took it up again,
after having renounced all personal eurythmy initiative for
more than three decades. During the long period of restraint
she had been lovingly following eurythmy's development. She
was aware of the work that was going on in many places. She
had preserved in her heart in unchanged purity her own special
relationship to the birth of eurythmy.

She was invited to give courses at training centres, she was
asked for advice, and she was asked especially to tell of
eurythmy's beginnings. For this she developed a wonderful,
unique presentation. She would describe the lessons which she
had been allowed to have with Rudolf Steiner, and in between
she showed, with inimitable lightness, grace and precision, the
gestures for the vowels and consonants, head positions and
foot positions, the soul gestures and rhythms. For the audi-
ence, the emergence of eurythmy 50 years before came to life
before their eyes.

Ruth Vogel (who was teaching at the Waldorf School in
Bremen) tells us of this time:

> Lory Maier-Smits came to Hamburg every year to teach at
> the small eurythmy school of Lotte Korff and to help with
> our artistic work [...] It was very important to Lory Maier-
> Smits that we eurythmists work together artistically—only
> by doing so would we be able to find ever new strength for
> teaching. She helped us to prepare small performances for
> the branch of the Anthroposophical Society. Her special
> concern was the differentiation of the sounds: little gestures,
> big gestures, gestures of hearing or seeing, gestures which
> take on the nuance of a soul mood [...] and so on.

I invited her to come to Bremen. So for eight years [from 1959–1966] she came every year. Since she always stayed with me, we occasionally had the most wonderful conversations about eurythmy until late into the night...

Every morning she went to the school with me to watch my lessons—often four hours in a row. The first time it was a Class Eight. We were doing rod exercises, head positions and foot positions. Here was an opportunity to show how skilfully, quickly and yet precisely the exercises can be done. 'Yes, Dr Steiner wanted us to heighten them to the point of virtuosity,' she said, and demonstrated the 'qui-qui' exercise. With amazement we watched her fingers dancing around the rod. So ... we set to work and it became a good clatter festival! Reviewing the lesson afterwards she said to me that I had turned my head too far for the head positions. At the next lesson she did these with the children herself and also the foot positions: large, expressively, and fast. How good my Class Eight pupils looked![98]

We can see from letters she wrote to Margarita Woloschin how strongly eurythmy once more came to rule her life. There were journeys of several weeks, with very exact, very detailed time-tables; she went for example to Kassel, Hamburg, Bremen, Ottersberg, Holland (where she also visited her youngest sister Thea Onnen-Smits), Hannover, Hamborn and Wuppertal. She gave courses at eurythmy schools—in Vienna at the school of Trude Thetter, in Florence at the school of Friedhelm and Ingrid Gillert, in Stuttgart at the school of Else Klink. And in 1960, when a move was being planned for the family, she wrote in a letter: '... if I were then to have a real eurythmy room, then I am sure that I would also get students.'

Lory was often asked to write down her memories of Rudolf Steiner and of the lessons she had been permitted to have with him. She hesitated. The form of the written word seemed to her to be totally inadequate compared with communication in person, which can be accompanied by expressive gestures. Her

Lory Maier-Smits.

friend M. J. Poturzyn, however, managed to persuade Lory to write two articles.

Yet when Eva and Edwin Froböse approached her in 1962 requesting an objective, chronological record of the indications she had received from Rudolf Steiner, for the documentation of eurythmy within the framework of the complete edition of his works—this was a new kind of challenge. She gave up her original restraint, for she realised that this was a part of Rudolf Steiner's work for which she alone carried the responsibility. She took on the task with her characteristic will-power.

It turned out to be a gift of destiny that she could now write down eurythmy's beginnings—for herself and for generations to follow. For herself personally it must have meant a culmination of her life's achievement, to give written form to the movements that she had developed with the forces of her youth, now at the level of reflective, understanding consciousness. And she succeeded here in fulfilling Rudolf Steiner's call to all teachers: '... you must learn to let your heart rise up into your head—not the opposite, your head going down into your heart...'. She wrote it with her heart.

The work on the manuscript was helped along by the loving interest and eurythmy experience of Eva Froböse. For Lory became very ill in the middle of the project. She lay in the Ita Wegman Clinic in Arlesheim from October 1962 to the end of March 1963, spending her seventieth birthday there. However, she did recover again and managed to finish the manuscript.

She continued teaching at various places until 1967, when she withdrew from the work. She had a stroke in 1971 and could no longer move or speak. She was cared for most lovingly by her relatives at home, by her daughter Anna Sophia and her daughter-in-law Christa. Also the relatives who did not live there came again and again to help, including her daughter Johanna Maria and her sister-in-law Olga Smits.

Lory left her earthly body on 19 September 1971.

On the day of the funeral, the Dornach and Stuttgart stage

groups were both on tour—so only teachers and students of the Stuttgart Eurythmeum travelled by bus to Lörrach for the cremation (on 24 September).They left Stuttgart very early in the morning. After they had passed through the Black Forest, the Rhine Valley lay before them and the sun rose, and there was a huge rainbow stretching over the Elsaß which remained there an unusually long time. On Michaelmas Day—29 September—at the Laufenburg cemetery, the urn was put into the earth.

The last photograph. Lory Maier-Smits with Margarita Woloschin.

Notes

1 Maier-Smits, Lory. *Mitteilungen aus der Anthroposophischen Arbeit in Deutschland.* Easter and Christmas 1951.

2 Krück von Poturzyn, M.J (editor). *Wir erlebten Rudolf Steiner.* Stuttgart: Verlag Freies Geistesleben, 1987.

3 Steiner, Rudolf. *Die Entstehung und Entwicklung der Eurythmie.* Dornach: Rudolf Steiner Verlag, 1982.

4 Translator's note: These first three sources will not be given a footnote each time for the English translation, however they will be indicated by quotation marks or indenting.

5 Steiner, Rudolf. *The Evolution of Consciousness as Revealed through Initiation Knowledge.* London: Rudolf Steiner Press 1991.

6 Steiner, Rudolf. *A Lecture on Eurythmy.* Lecture: 26 August 1923. London: Rudolf Steiner Press, 1967.

7 Meffert, Ekkehard. *Mathilde Scholl und die Geburt der Anthroposophischen Gesellschaft.* Dornach: Verlag am Goetheanum 1991.

8 Steiner, Rudolf. *Zur Geschichte und aus den Inhalten der ersten Abteilung der Esoterischen Schule 1904 bis 1914.* Dornach: Rudolf Steiner Verlag, 1984.

9 He said 'Sie' instead of 'du,'—really very formal for an eleven year-old in Germany. Translator's note.

10 Steiner, Rudolf. *Natur und Geistwesen—ihr Wirken in unserer sichtbaren Welt.* Dornach: Rudolf Steiner Verlag, 1983. From the notes of someone who was not a professional stenographer.

11 Steiner, Rudolf. *The Spiritual Hierarchies and the Physical World.* New York: Anthroposophic Press, 1996.

12 The forces in the human organism which cause it to live, grow and reproduce. Translator's note.

13 Steiner, Rudolf. *Metamorphosis of the Soul,* Vol. 2. Lecture: 3 February 1910. London: Rudolf Steiner Press, 1983.

14 Steiner, Rudolf. *Cosmic Memory. Prehistory of Earth and Man.*

Chap.: The Lemurian Race. London: Rudolf Steiner Publishing Co., 1959.

15 See note 10.

16 Steiner, Rudolf. *Esoteric Christianity and the Mission of Christian Rosenkreutz*. Lectures: 27 and 29 January 1912. London: Rudolf Steiner Press, 1984.

17 It is the sound, not the sense, that is important in such exercises, therefore an approximation of the 'sound-shape' of the original German has been given in brackets.

18 Translation by Matthew Barton. Original:

'So steht ein Kreuz inmitten Glanz und Fülle
Auf Golgatha, glorreich, bedeutungsschwer
Verdeckt ist's ganz von seiner Rosen Hülle,
Längst sieht vor Rosen man das Kreuz nicht mehr.'

19 See note 16.

20 Steiner, Rudolf. *The Story of My Life*, chap.: XXXI and XXXIV. New York: Anthroposophic Press, 1951.

21 Schuré, Edouard. *The Great Initiates*. New York: Rudolf Steiner Publications, 1961.

22 Steiner, Rudolf. *Four Mystery Plays*. London: Rudolf Steiner Press, 1982.

23 The vowel-sounds in brackets are the English equivalent of the German vowels. 'O' is roughly the same in both languages.

24 Steiner, Rudolf. *The Gospel of Saint Mark*. Lecture: 15 September 1912. London/New York: Rudolf Steiner Press/ Anthroposophic Press, 1986.

25 Steiner, Rudolf. *Die Beantwortung von Welt- and Lebensfragen durch Anthroposophie*. Dornach: Rudolf Steiner Verlag, 1986.

26 Old Testament, Psalm 104, verses 1–23.

27 'Über die Pantomime.'

28 Study of the unity of dance, gesture, poetry and music in ancient Greece. Leipzig, 1898.

29 Translation by Matthew Barton. Original:

Kühnheit, wenn sie sich eint mit Weisheit,
Bringet dir Segen.
Wandelt sie aber allein,
Folget Verderben ihr nach.

30 Silence reigns o'er deepest ocean,
 still the sea without a sound,
 and uneasy sees the sailor
 glassy smoothness all around.
 Not a breath from any quarter,
 horrid stillness like the grave.
 Over wide tremendous water
 not a single moving wave.
 (translation by Virginia Brett)

 'Meeres Stille'
 Tiefe Stille herrscht im Wasser,
 Ohne Regung ruht das Meer,
 Und bekümmert sieht der Schiffer
 Glatte Fläche rings umher.
 Keine Luft von keiner Seite!
 Todesstille fürchterlich!
 In der ungeheurn Weite
 Reget keine Welle sich.

31 'The mists are tearing, the heavens are bright, and Aolus
 loosens the anxious bonds. The sailor is stirring. Quickly,
 Quickly! The wave is parting, the distance approaches; I see the
 land!' Original:

 'Glückliche Fahrt'
 Die Nebel zerreißen,
 Der Himmel ist helle,
 Und Äolus löset
 Das ängstliche Band.
 Es rührt sich der Schiffer.
 Geschwinde! Geschwinde!
 Es teilt sich die Welle,
 Es naht sich die Ferne;
 Schon seh ich das Land!

32 'Cover your sky, Zeus, with vaporous clouds, and try out, like a
 boy knocking the heads off thistles, your strength against oak
 trees and mountain-tops: you still must leave me my earth
 standing, and my hut which you did not build, and my hearth
 for whose warm glow you envy me.

'I know of no poorer thing under the sun than you gods!
Wretchedly you feed your majesty on sacrificial offerings and
the breath of prayers, and you would starve if children and
beggars were not fools full of hopes...' Translation, footnotes
42, 43: Luke, David. *Goethe. Selected Verse.* Harmondsworth:
Penguin Books Ltd, 1964.

33 Steiner, Rudolf. *Der Goetheanum Gedanke inmitten der Kul-
terkrisis der Gegenwart.* Dornach: Rudolf Steiner Verlag, 1961.

34 'Über Verkehr mit den Toten.'

35 'Hymn to the Morning'
Each creature cries:
 It's day!
 It's life!
 It's love!
In the shadows
sail-like
the heavens unfold.
A veil of cloud
floats up and hovers,
circling in a vortex.
The dark shroud rends,
a scarlet foam begins
to spark and glow.
The sun steps forth,
treading the chaos
of tattered shapes.
Space is aflame
Where his foot has trod.
Dark still, the earth
lifts up to him
its thirsting flanks.
The shadow fades,
light floods the wave,
many-hued the peaks
of mountains glow.
For everything is rayed
with golden rain.
All lives and cries,

It's day!
It's life!
It's love! (Translation by Theodore van Vliet.)

36 Original:

Der Wolkendurchleuchter:
Er durchleuchte,
Er durchsonne,
Er durchglühe,
Er durchwärme,
Auch mich.

37 'oi' as in oil.
38 'Wiegenlied.'
39 'denn sie schickt den Eurythmisten / die allerschönsten Kleiderkisten.'
40 Steiner, Rudolf. *Life between Death and Rebirth*. Lecture: 27 April 1913. New York: Anthroposophic Press, 1968.
41 ibid.
42 ibid.
43 Translation by Theodore van Vliet. Original:

Die Bergeshöhn warum so schwarz?
Woher die Wolkenwoge?
Ist es der Sturm, der droben kämpft,
Der Regen, Gipfel peitschend?
Nicht ist's der Sturm, der droben kämpft,
Nicht Regen, Gipfel peitschend;
Nein, Charon ist's, er saust einher;
Entführet die Verblichenen;
Die Jungen treibt er vor sich hin,
In Reih gehenkt am Sattel.
Da riefen ihm die Greise zu,
Die Jünglinge, sie knieten:
'O Charon, halt! halt am Geheg,
Halt an beim kühlen Brunnen!
Die Alten da erquicken sich,
Die Jugend schleudert Steine,
Die Knaben zart zerstreuen sich
und pflücken bunte Blümchen.'

'Nicht am Gehege halt ich still,
Ich halte nicht am Brunnen;
Zu schöpfen kommen Weiber an,
Erkennen ihre Kinder;
Die Männer auch erkennen sie.
Das Trennen wird unmöglich.'

44 Steiner, Rudolf. *Eurythmy as Visible Speech*. London: Rudolf Steiner Press, 1984.
45 Dubach-Donath, Annemarie. *Was in der Anthroposophische Gesellschaft vorgeht*. 17 October 1971.
46 Woloschin, Margarita. *Die grüne Schlange*. Stuttgart, 1956.
47 Kisseleff, Tatjana. *Eurythmie. Erinnerungen aus den Jahren 1912–1927*. Karlsruhe, 1949.
48 Bauman, Elizabeth. *Aus der Praxis der Heileurythmie*. Dornach, 1983.
49 On the afternoon of 28 August 1913 in the Kaimsaal of the Turnhalle, Türkenstraße, Munich.
50 See note 48.
51 See note 46.
52 See note 48.
53 Turgenieff, Assja. *Erinnerungen an Rudolf Steiner*. Stuttgart, 1972.
54 'Ich bin da.'
55 'Ich schaue auf.'
56 Steiner, Rudolf. *The Fifth Gospel*. London: Rudolf Steiner Press, 1995.
57 'Genuine Chinese handmade bronze cymbals which gave a full bell-deep resounding tone, when properly struck.' Baumann, Elisabeth. See note 48.
58 See note 48.
59 'Kritik der Sprache.'
60 Translation by Virginia Brett. Original:

'Hyperions Schicksalslied'
Ihr wandelt droben im Licht
Auf weichem Boden, selige Genien!
Glänzende Götterlüfte
Rühren euch leicht
Wie die Finger der Künstlerin
Heilige Saiten.

Schicksallos wie der schlafende
Säugling, atmen die Himmlischen;
Keusch bewahrt
In bescheidener Knospe
Blühet ewig
Ihnen der Geist,
Und die Augen
Blicken in stiller
Ewiger Klarheit.

Doch uns ist gegeben,
Auf keiner Stätte zu ruhn,
Es schwinden, es fallen
Die leidenden Menschen
Blindlings von einer
Stunde zur andern,
Wie Wasser von Klippe
Zu Klippe geworfen,
Jahrlang ins Ungewisse hinab.

61 A dialect spoken in North Germany that is sightly more similar
 to English than ordinary German.
62 *Mitteilungen für Mitglieder der Anthroposophische Gesellschaft.*
 June 1914.
63 Steiner, Rudolf. *Das Geheimnis des Todes.* Dornach: Rudolf
 Steiner Verlag, 1980.
64 Translation by Virginia Brett. Original:

'Mahomets Gesang'
'Seht den Felsenquell
Freudehell,
Wie ein Sternenblick!
Über Wolken
Nährten seine Jugend
Gute Geister
Zwischen Klippen im Gebüsch.
Jünglingfrisch
Tanzt er aus der Wolke
Auf die Marmorfelsen nieder,
Jauchzet wieder
Nach dem Himmel...'

65 'Schwalben.'
66 'Kurze rasche Bogen schlagend.'
67 'Vereinsamt.'
68 'Dichters Berufung.'
69 'Ja, mein Herr, Sie sind ein Dichter, Achselzuckt der Vogel Specht!'
70 Steiner, Rudolf. *Geisteswissenschaftliche Erläuterungen zu Goethe's 'Faust'*. Dornach: Rudolf Steiner Verlag, 1981.
71 Preludes; eurythmists usually use the original German term 'Vortakt.'
72 Steiner, Rudolf. *Wahrspruchworte*. 'Zwölf Stimmungen.' Dornach: Rudolf Steiner Verlag, 1991.
73 Steiner, Rudolf. *Human and Cosmic Thought*. London: Rudolf Steiner Press, 1991.
74 Fels, Alice. *Vom Werden der Eurythmie*. Dornach: Verlag am Goetheanum, 1986.
75 Maier, Reinhold. (Minister President of Baden-Württenberg after W.W.II.) Private memoirs for family and friends.
76 Kühn, Hans. *Dreigliederungszeit*. Dornach: Verlag am Goetheanum, 1978.
77 'Der Ritt in den Tod.'
78 Steiner, Rudolf. *Kunst und Kunsterkenntnis*. Dornach: Rudolf Steiner Verlag, 1985.
79 Steffen, Albert. *Begegnungen mit Rudolf Steiner*. Dornach: Verlag für Schöne Wissenschaften, 1975.
80 Steiner, Rudolf. *Unsere Toten*. Dornach: Rudolf Steiner Verlag, 1984.
81 'Liebeserklärung.'
82 Original:

 'Liebeserklärung'
 O Vogel Albatros!
 Zur Höhe treibt's mit ewgem Triebe mich.
 Ich dachte dein: da floß
 Mir Trän um Träne,—ja, ich liebe dich!

83 'Nachtakt' means 'postlude.' Since English-speaking eurythmists usually use the German term, it has been retained in this translation.
84 Translation by Virginia Brett. Original:

'Séance'
Hier ist's, wo unter eignem Namen
Die Buchstaben sonst zusammenkamen.
Mit Scharlachkleidern angetan
Saßen die Selbstlauter obenan...
Die Mitlauter kamen mit steifen Schritten,
Mußten erst um Erlaubnis bitten.
Präsident A war ihnen geneigt;
Da wurde ihnen der Platz gezeigt...

85 Translation by Virginia Brett. Original:

'Die Hystrix'
Das hinterindische Stachelschwein
(hystrix grotei Gray),
das hinterindische Stachelschwein
aus Siam, das tut weh.

Entedeckst du wo im Walde drauß
bei Siam seine Spur,
dann tritt es manchmal, sagt man, aus
den Schranken der Natur.

Dann gibt sein Zorn ihm so Gewalt,
daß, eh du dich versiehst,
es seine Stacheln jung und alt
auf deinen Leib verschießt.

Von oben bis hinab sodann
stehst du gespickt am Baum,
ein heiliger Sebastian,
und traust den Augen kaum.

Die Hystrix aber geht hinweg
an Leib und Seele wüst.
Sie sitzt im Dschungel im Versteck
und büßt.

86 See note 46.
87 Otto, Johanna. Private notes.
88 ibid.
89 She died on 3 April 1948, at age 85.
90 Vogel, Ruth. *Rundbrief für Eurythmisten, Sprachgestalter, Schauspieler, Musiker.* Dornach, 1993.